PAINTING
FOR CALLIGRAPHERS

T

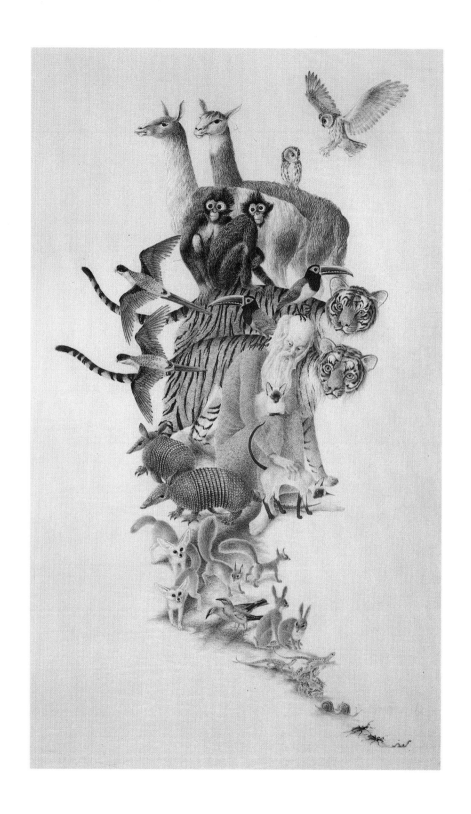

MARIE ANGEL

PAINTING
FOR CALLIGRAPHERS

PELHAM BOOKS

ACKNOWLEDGEMENTS

PELHAM BOOKS

Published by the Penguin Group
27 Wrights Lane, London W8 5TZ
England
Viking Penguin Inc., 40 West 23rd Street
New York, New York 10010, USA
The Stephen Greene Press, 15 Muzzey
Street, Lexington, Massachusetts 02173
USA
Penguin Books Australia Ltd, Ringwood
Victoria, Australia
Penguin Books Canada Ltd, 2801 John
Street, Markham, Ontario, Canada
L3R 1B4
Penguin Books (NZ) Ltd, 182-190 Wairau
Road, Auckland 10, New Zealand

Penguin Books Ltd, Registered Offices:
Harmondsworth, Middlesex, England

First published 1984
Reprinted 1985, 1989

Made and printed by New Interlitho

A CIP catalogue for this book is available
from the British Library

ISBN 0 7207 1415 X

I would like to thank all those who so kindly loaned me work for
illustrating this book: Richard Harrison, Philip Hofer, Charles and
Elizabeth Pizzey, and Nancy Stanfield; also my gratitude for all the
willing assistance given me by the Librarian and staff of Caterham
Valley Library. To Dorothy Mahoney my very appreciative thanks
for her constant enthusiasm, encouragement and experienced criticism
throughout. My thanks are further due to Bob Eames, the book's
designer, and I am particularly grateful to Muriel Gascoin for her con-
structive and practical assistance and expert guidance during the writing
and assembly of this book.

Illustrations: photographs of contemporary work are reproduced by per-
mission of the artist; photographs of historic manuscripts and paintings
are reproduced by permission of the British Museum (page 46); the
British Library (pages iv, 19, 24 (*right*), 36, 43, 82, 87, 90, 93 and
108); the India Office Library, London (page 54); the Victoria and
Albert Museum (pages 42, 57, 58 (*top*), 60, 72, and 75); the Board
of Trinity College, Dublin (page 66). The illustrations on pages 13
and 27 are from manuscript pages in the author's possession, as is the
illustration on page 56 from Curtis's *Botanical Magazine*. The photo-
graph of the *Lakeland Flower Tapestry* on page 114 was kindly loaned
by the Holburne Museum, Bath. The photographs on pages ii, 13,
18 (*right*), 21, 27, 29 (*bottom*), 38 (*colour*), 39, 40, 45, 47–50, 52, 56,
62, 64, 65 (*right*), 78, 95 (*bottom*) and 115 were specially taken for this
book by Peter Hutchings.

CONTENTS

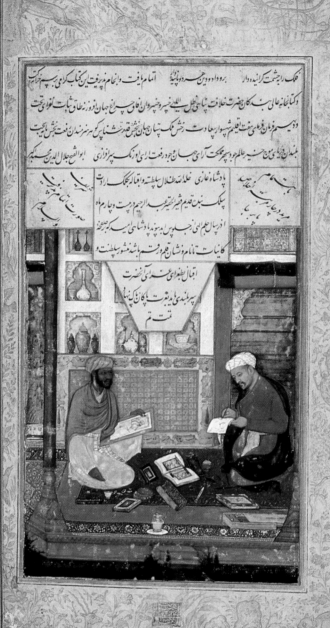

FOREWORD

Since writing *The Art of Calligraphy* I have received an increasing number of requests to explain more fully my method of painting miniatures.

My first intention was to write quite a short book on this subject, but soon found I was assuming that the reader had a good knowledge of the basic principles and methods of painting, such as a student might receive at an art college.

However, the majority of would-be calligraphers today are unlikely to have this training, so I have tried to give some information on fundamental methods and techniques in an effort to overcome the problems most likely to arise when amateur calligraphers want to decorate their manuscripts.

Although this book aims to be helpful to anyone who wishes to paint miniatures, I have assumed the reader to have a knowledge of calligraphy. For those who do not and would like to learn something of the subject, I suggest they study either Dorothy Mahoney's *The Craft of Calligraphy* or my own book *The Art of Calligraphy*.

I also thought it would be most valuable for students to read how other well-known scribes produce their immensely varied work and have included a chapter on their individual methods. I am grateful to all those who sent notes and co-operated on this chapter of the book: Dorothy Mahoney, Thomas Ingmire, Joan Pilsbury, John Prestianni, Sheila Waters, Wendy Westover and John Woodcock. Sadly, Ida Henstock, who took so much trouble to find me photographs and transparencies of her unique style of painting, died last year without seeing the book in which she took a great interest. My thanks are due here also to David Graham who photographed so much of Ida Henstock's work.

MARIE ANGEL
1983

MATERIALS

Buying materials today can be expensive; so while I have tried to list all the things one might need to carry out a piece of work, it is a good idea – if you are a beginner – to buy the minimum until you have experimented a little and decided on your personal preferences. A prac, tising calligrapher will already own most of the items listed.

DRAWING BOARDS

Drawing boards of some sort are essential. They can be bought in vary, ing grades and prices – buy the best you can afford. A good wooden drawing board will last a lifetime if properly cared for.

For most calligraphers, a medium-sized board is sufficient for the decorating of manuscript books and smaller broadsheets, etc. If you want to make really big wall decorations or large manuscript books, then you would obviously need a larger board. Some calligraphers use a large table-top or even the floor. My own preference for painting is a moveable board which can be tilted from knee to desk and the angle varied as the need arises. I have never been able to paint on the fixed-slope desk so ideal for writing.

To begin with, a stout piece of plywood would make a good board; hardboard may also be used for small work or for stretching paper of small size.

PENCILS

It does not pay to economise on pencils: buy a good, well-known brand of drawing pencil. Cheap pencils feel gritty, may give an intermittent line and are often difficult to sharpen as the wood, too, is of poor quality.

Lead pencils are made from graphite and clay – the more graphite in the mixture, the softer and darker the line will be. Pencils come in various grades and it is important to appreciate their different qualities. In H (Hard) pencils, there are nine grades (9H–H); the higher the number, the harder the pencil lead and the lighter the line it makes. HB, the dividing point between hard and soft pencils, is a general purpose, medium grey and very useful for most work. B (Black) pencils feel very soft compared with the H grades and give a rich, black line, especially in the upper grades; these range from 6B, the softest and blackest, to B. There is also an F grade, which is blacker than an HB, but does not smudge so easily as a B pencil. I often use an F pencil for plant drawings.

Pencils for vellum

For work on vellum, unless you are a very skilled draughtsman, disre, gard the B pencils altogether and buy the very hard 6H, a 3H or 2H, and an HB. When used on vellum, a soft pencil rubs off very easily and smudges the surrounding surface of the vellum with disastrous re, sults, since it is not easy to clean it up without bruising the delicate

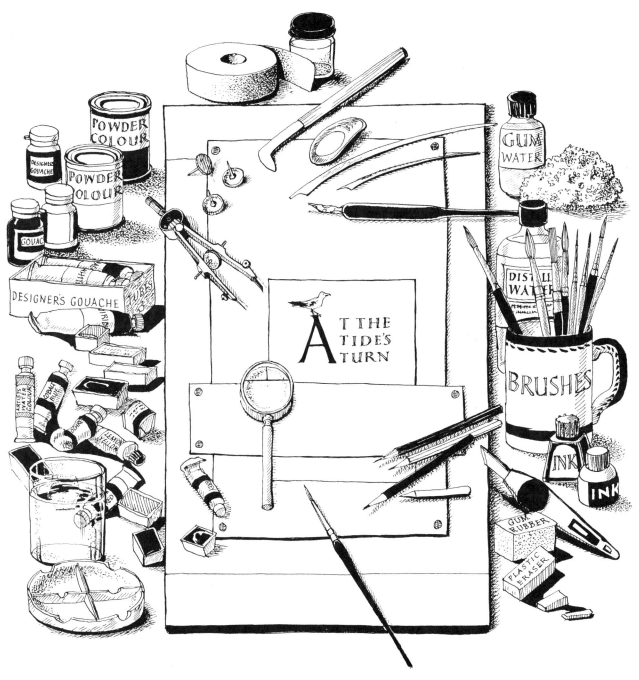

Materials and tools likely to be used by a painter of
illuminated manuscripts or miniatures.

surface of the skin. Most calligraphers use a very sharp, hard pencil, such as 6H, for ruling lines and this is just as good for drawing on the vellum.

Pencils for paper For drawing on paper, it is better to use a softer pencil than one would on vellum, as a sharp 6H gives only the faintest grey line. HB is good for most work and a B or 2B will give a more mellow line. I often use the softer grades of B, but this is a personal choice, as I like the feel of the softer pencil and the blacker line it gives. If you want to use a softer pencil, be sure of your ability to put down your line on the surface without making any corrections – softer pencils smear quickly and so cause more hazards for the beginner. Slip a clean piece of thin paper under the drawing hand to protect the surface and the drawing as you work over it.

ERASERS If you need erasers, there are a variety to choose from. Soft rubber or vinyl are suitable for pencil work on paper, and for vellum new bread or gum rubber. Plastic or rubber erasers may be sliced into thin pieces for erasing small details without damaging the rest of the drawing. A hard rubber, such as the kind that typists used before correcting fluid was available, is good for cleaning up mistakes on vellum. It is import⁄ant that any erasure – on vellum particularly – should be made with a material which does not harm the surface and does not rub the pencil into black smears.

 Many calligraphers when writing use pumice to help in erasures. I do not recommend this practice when erasing part of a painting, as it damages the surface so much that painting over it will be difficult and the erasure will always be visible.

KNIVES A sharp knife is essential. It should have a good quality blade. You will need to sharpen pencils to a really fine point: I keep mine as sharp as needles. A craft knife, the kind for which replacement blades can be bought, is excellent.

 You will also need another knife with a very sharp blade for erasing colour from vellum. Most calligraphers will already own a quill knife which may be used for this purpose.

Three drawings to show the varying degrees of sharpness of line and depth of tone produced by different grades of pencil.

PENS Reed, quill, and steel⁄nibbed pens are all useful for writing or drawing in colour. Felt or fibre⁄tipped pens may be used on paper, but I do not think this is advisable. Like coloured inks, they are not light⁄fast and the chance of them remaining unchanged in colour for years is small. Use them for fun – for something ephemeral – but do not use

them for a precise piece of work which is intended to stand the test of time.

COLOURS
Powder colours

Artists' powdered colours are pure and strong, but they have to be used with a suitable medium such as egg or gum water to fix them to the surface of the page. These ready-ground powdered pigments are the nearest to the type of colours that mediaeval painters prepared for themselves from raw materials.

Tube colours

Tube colours are very convenient to use, as one may measure the quantity squeezed out onto a palette when mixing colours for work in hand. The tube of colour will also remain clean and moist indefinitely as long as the cap is replaced immediately after use. Tube colours are already mixed with gum arabic and glycerine and only have to be thinned with water. I nearly always use Winsor and Newton's Artists' watercolours in tube form.

Cake colours

Cake colours are small rectangles of prepared colour wrapped in paper; they are also sold in china pans and half-pans. With these colours the pigment has already been mixed with gum arabic. There is usually no glycerine in pan colours which makes them less sticky to handle and in some ways better for work on vellum, especially for beginners. However, the surface of the pan colour has to be moistened with the brush to loosen the colour: this can be tedious work, particularly when mixing a large quantity of colour.

Gouache colours

Gouache colours are brilliant in hue and have a very good opaque, matt surface when dry. They keep well in the tubes or small pots in which they are sold. Those called 'designers' colours' are the best quality. The colours are rich and easily mixed together and can be used for large areas of colour on broadsheets, etc; they may be thinned down with water, but tend to look coarser than transparent watercolour.

Gouache colours can be mixed with other watercolours, and I sometimes use them in this way to make a particular colour or to achieve a special effect.

COLOURED INKS

Coloured inks are made from dyes and come in many brilliant and intense colours. The effects obtained from these transparent colours are impossible with watercolour. Some illustrators use these inks very effectively. They are not, however, suitable for use on vellum or paper for any serious work, as they are not very lightproof. If you want to use them, try them out first and expose them to strong light for two or

three weeks. (A method for colour testing is given below on page 26.) Mediaeval illuminations are as rich and bright today as when they were first painted. One should always be concerned for the permanence of one's work.

BRUSHES

The finest brushes made for watercolour painting are Russian red sable. If they are well cared for, these brushes keep their points longer, have a lovely sensitive feel in use, are springy, and last longer than any other type of watercolour brush. They are also expensive. I find Winsor and Newton's series 3A sizes 0–3 indispensable for my work. This series of brushes has rather longer hair than other small sable brushes, which gives them a greater degree of movement, and they hold colour better than a brush with shorter hair.

For beginners, and for economy, watercolour brushes in other sorts of hair, such as squirrel and ox-hair, are quite usable. These brushes will not have the same long life as the sable, as the hair is softer and the point is lost sooner. However, old brushes can be kept and used for loading pens, mixing colours, filling in backgrounds, and any other odd job which will save one's best sable points for the finest work.

Brushes may be bought with differently shaped heads. I like round-headed brushes for miniature work where a very fine point is needed. Chisel-headed brushes may be used for lettering and big mop-headed brushes for laying down large areas of colour.

It is now possible to buy brushes made of synthetic materials, such as nylon and polyester. They do not hold colour as well as a brush made with hair, do not make such a good tip, and are less sensitive in use; but they are strong and cheaper than hair brushes.

A good brush should last for years, if it is properly treated; that is, washed out after use, the tip reformed, and left to dry in an upright position in a jar. Take care to protect the tip at all times.

SHELL GOLD

For gilding, you will need shell gold. Shell gold is so-called because it is often in mussel shells when bought ready prepared. It is easier to buy it in this prepared state than to make it.

To prepare it for oneself, leaf gelatine or very refined powdered gelatine is required as well as the powdered gold. (For methods of making shell gold, see pages 91 and 110.)

When prepared, the shell gold is used with distilled water and a fine sable brush. Brushes for gold should be kept for this purpose only. Keep the distilled water in a screw-topped jar as it will contain powdered gold from washing the brushes and this gold may be re-used.

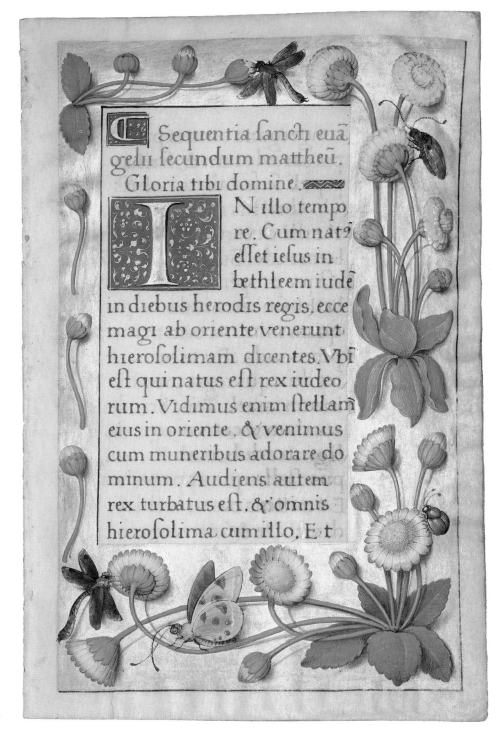

Page from a manuscript of the Bourdichon school. Late 15th to early 16th century. Body colour and shell gold on vellum. $6\frac{7}{8} \times 4\frac{3}{8}in$ (175 × 111mm). Mediaeval illuminators used large areas of shell gold as backgrounds for decorative borders. The daisy plants and insects in their naturalistic style are very typical of the period. The shell gold is burnished.

If you wish to burnish the shell gold, you will need an agate burnisher.

VELLUM Vellum may be bought as a whole skin or in pieces cut to the size of page required. Pieces cut to size are usually more expensive overall than buying a whole skin, but for the higher price one is getting the best part of the skin and no wastage. For miniature painting or for very small pieces of work, stockists usually sell off-cuts; these are also useful for experimenting with colours or different techniques.

For small pages, thin skins are necessary and for larger pages thicker vellum may be used.

The spine of the skin should run from the head to the foot of the page – never cut vellum into pages with the spine of the skin running across from left to right horizontally.

Vellum has a 'hair' and a 'flesh' side: the hair side is the nicer surface and is the one from which the hair grew; the flesh side may need some preparation and one may have to avoid 'veins' and other hazards on the skin surface.

For my work, I like to use a thin, or very thin, manuscript vellum with preferably an unnapped surface. When writing and painting on a sheet of vellum avoid preparing the spaces left for the paintings. For fine miniature paintings, you should never prepare the vellum overmuch – if at all. The soft, velvety surface so correct for writing on with a sharp, chisel-edge pen is hopeless for fine painting. This is because the tip of the brush is too soft to cut through the nap and it can prove difficult to get the colour on at all – especially if much sandarac has been used. It is impossible to achieve a sharp line with a fine brush on a napped surface.

For a large book or broadsheet, heavier manuscript vellum may be more suitable. These heavier vellum skins often have a smoother surface and are excellent to paint on.

Choose interesting colours or markings on some skins as these may fit the mood of the text and the subject of the painting one contemplates; by using the background markings with skill, the painting and the calligraphy may be enhanced.

PAPER Buy the best paper that you can afford: cheap paper is useful for rough work and for practising on, but poor quality paper will discolour and become brittle after a short time.

The best paper is hand-made from linen rags. However, it is the most expensive and difficult to obtain. Most rag papers today are made from cotton.

MARIE ANGEL
*Gold-laced polyanthus. Unfinished watercolour
drawing on stretched Green's handmade paper.
4 × 3¼in (102 × 83mm). This type of work is
always better on a stretched surface : the preliminary
washes are quite fluid and the paper would undoubtedly
wrinkle unless previously stretched. A simple outline
has been drawn with an F grade pencil before applying
colour.*

A good cartridge paper with a smooth surface is suitable for beginners, although it would not necessarily be a good surface for calligraphy. Green's and Whatman papers are excellent. Some Fabriano papers are suitable for both painting and writing; coloured papers, such as Ingres, have an interesting texture.

Because of its smooth surface, a hot-pressed paper makes it easier to write on and for painting fine details. A good hand-made paper rarely needs any preparation before using it for painting other than stretching, which prevents the paper from wrinkling, if one should over-wet it. Whether one needs to stretch the paper will be decided by the type of painting to be done.

Hand-made papers have a watermark which reads from the right side of the paper; either side of a good paper may be used for painting, unlike vellum where the hair side invariably gives the best results.

Like vellum, paper should be light and thin for small books and heavier for larger ones. Remember that a thin, hand-made paper will 'show through' quite considerably if much paint is used – more so than a thin sheet of manuscript vellum.

15

STRETCHING
Vellum

Vellum is sensitive to atmospheric conditions and will quickly shrink and curl up when exposed to hot, dry air, or stretch and wrinkle when the atmosphere is damp and humid. Because of this sensitivity, large pieces of vellum used for broadsheets must be stretched before framing. This is best left to an expert such as a picture-framer.

Small pieces of vellum for miniatures may be mounted on stout card using flour paste. Apply the paste to the board, then smooth the piece of vellum down on to it and place under pressure – between heavy books is sufficient weight – for a day or so.

When vellum is to be stretched, any calligraphy, other than painted decoration and gilding, should be done first.

Vellum used for pages of a book is not stretched, so within such a book one should confine decoration to a technique which does not need large, flat washes.

Paper

It is always worthwhile to stretch paper used for broadsheets, although a thick, heavy paper may lie flat without stretching, even when a wash technique is used.

Paper used for book pages need not be stretched, providing one is not using such large washes in the decoration of the manuscript that wrinkling will occur.

If the decoration is going to need large, wet washes liable to make the paper wrinkle, it would need to be stretched after any written work has been completed and before painting. For beginners, stretching in these circumstances is best left to an expert, as excessive damping may loosen the ink which is not waterproof.

It *is* possible to write on paper after it has been stretched, although it is not easy.

Painted letters should be put in after stretching, as should shell gold or other decoration.

Stretching Paper

To stretch paper successfully, it must first be dampened and then all the edges completely sealed down onto a board. This can be done by dampening the surface with a sponge filled with clean water and sticking the edges down with paste directly to the board, but the method I have always used is as follows:

1 Cut four pieces of 1in-wide (25mm) paper-tape; each piece of tape should be at least 2in (50mm) longer than the length of paper it is to cover.
2 Lay the paper to be stretched right-side-up on a stout drawing board.
3 Dampen the surface of the paper with the wet sponge. The paper will wrinkle. There is no need to make the paper very wet.

16

4 Leave the paper for a few minutes to absorb the moisture. Smooth it out gently and then secure it to the board with the gummed paper-tape, overlapping half the width of the tape on the paper and half on the board. Press the tape firmly down along each side of the paper to make sure that there is a complete seal all round.

5 Leave the paper to dry on the board, away from direct heat, and flat on a table or floor. As the paper dries, any wrinkling left by the dampening flattens out and the paper should become very taut and smooth.

Paper stretched in this way will remain flat even if large washes of watercolours are used on it.

TRACING PAPER

Tracing paper is a necessity for planning a layout. This may be bought either as rolls in continuous lengths suitable for very large work, or in sheet form as tear-off pads for smaller designs.

BINDING MEDIA

Binding media used in painting include distilled water, gum arabic, gum water, and egg. Gum water is a mixture of gum arabic and water already made up by a colour merchant.

OTHER MATERIALS

Palettes with compartments are practical, but any white china saucer or small jar may be used for the same purpose. White is the best background on which to mix colours – otherwise the colour could be affected by a coloured background showing through a transparent paint.

Clean rags, paper tissues, a small natural sponge and good quality, white blotting paper are all useful for cleaning brushes and palettes, and erasing or blotting colour.

Blotting paper also makes a good padding behind paper or vellum.

Tape for stretching paper should be of the kind that is made of paper and is moistened with water. Synthetic tapes, such as Sellotape, are of no use for this purpose as they will not adhere to a moist surface.

Rulers, a pair of compasses, dividers, set squares and T-squares are drawing instruments one is likely to use frequently.

COLOUR

Colour makes a direct appeal to the senses and has a more immediate impact than composition or form. It is important to cultivate a colour sense, for a contemporary calligrapher no longer uses only the traditional red, blue, green, purple and black hues with gold and silver as in the old manuscripts and heraldry.

Many calligraphers today make more broadsheets and wall-panels than books, expressing themselves freely in a strongly individual manner. Their reaction to the mood of the chosen text is emotional and often interpreted through colour; for example, important words in the text being stressed in a different colour from the main body of writing. Some of these works now verge on 'fine art' – legibility and form becoming less important to the scribe than the interpretation of the theme and the composition as a whole, while there is a definite trend towards

MARIE ANGEL
Initial C with Chameleon. Cypher commissioned by Philip Hofer. Watercolours on vellum. 2½ × 2¼in (64 × 57mm). Houghton Library, Harvard University. The rounded back of the chameleon completes the circle of the initial; the circle is repeated in the eye and the rolled-up tail.

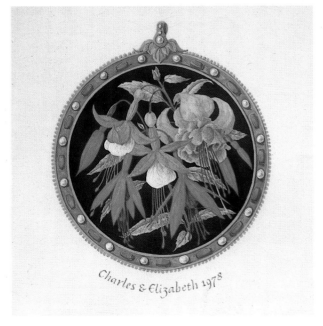

MARIE ANGEL
*Medallion miniature of fuchsias painted for Charles
and Elizabeth Pizzey for their Ruby Wedding.
Watercolours on vellum. $2\frac{7}{8} \times 2\frac{3}{8}$ (73 × 60mm).
The flowers, buds and leaves were all arranged to
oppose the circular shape: none of the curved shapes
are concentric with the background circle. The white-
petalled fuchsias were placed towards the centre to
draw the eye into the painting; the dark green
background is complementary to the reds and
accentuates them.*

subtle and expressive colour schemes. These works are nearer in essence
to Japanese and Chinese paintings where calligraphy, drawing and
colour play equal parts in the representation of an idea.

Colours evoke an emotional response in most people. Partly, this
is personal preference – likes and dislikes – and partly cultural associa-

tions. Colours such as black and purple are related in Western minds with mourning and death, so sombre shades can be used to symbolise fear and evil, gloom and melancholy. However, a *rich* purple is a symbol of majesty: vellum dyed purple (and then enriched with burnished gold letters) makes a magnificent and splendid page.

Bright red strikes the eye so instantly that it has long been used for war-like symbols and for signs warning of danger; it denotes courage, anger and strength; it can also be an exciting, happy, warming colour. One Vermilion capital will vitalise a whole page of black text. Yellow and orange are sunny, cheerful colours in their hues and tints. Green has a cool, refreshing quality and is an excellent foil for most other colours. Blue has serene, peaceful, heavenly associations – it is, after all, the colour of clear skies and summer seas – but some blues can be harsh and strident, and some sad, and symbolic of depression.

Colour is an experience rather than an actual thing. Not only do we each see colour differently through our eyes, we also interpret it in our minds in a different way. We all, as individuals, assess the colours we see according to our own experiences and personality. If one shows a group of people a colour deliberately mixed to be on the borderline between blue and green and asks them to assign it to one colour or the other, some will say it is blue and some green, some a bluish-green or greenish-blue. The way one handles colour, therefore, will be as individual as one's handwriting.

COLOUR THEORY

Colour is light – without light there would be no colour. The effect of light on colour changes it constantly. The brighter the light, the more intense the colour becomes. To view colours carefully or to match colours we take them to the light; in the dark they are all various shades of grey and black.

Red, for all its bright intensity, is the first colour to fail as night falls – blues and greens will last longer; light yellows and white remain visible even in deep dusk – a circumstance which gardeners use to advantage by planting flowers in these colours to extend beyond sunset the pleasure we get from looking at our borders. Night-flowering plants usually have light blooms which attract the night-flying insects for pollination. In studio conditions, light may be controlled to some extent, but anyone who has tried to paint out of doors will know how quickly the light changes according to the position of the sun, clouds, and other atmospheric variations. It is this viewing of colours through the atmosphere around us, the constantly changing air through which they are seen, which results in the infinitely subtle variations of colour we are challenged to capture.

Opposite: MARIE ANGEL
Trout. Illustration from Bird, Beast and Flower *(Chatto and Windus/David Godine). Watercolours on vellum. $6\frac{1}{4} \times 5in$ (160 × 127mm). An example of an harmonious colour scheme achieved by using colours from one half of the colour circle only – blue, green, yellow.*

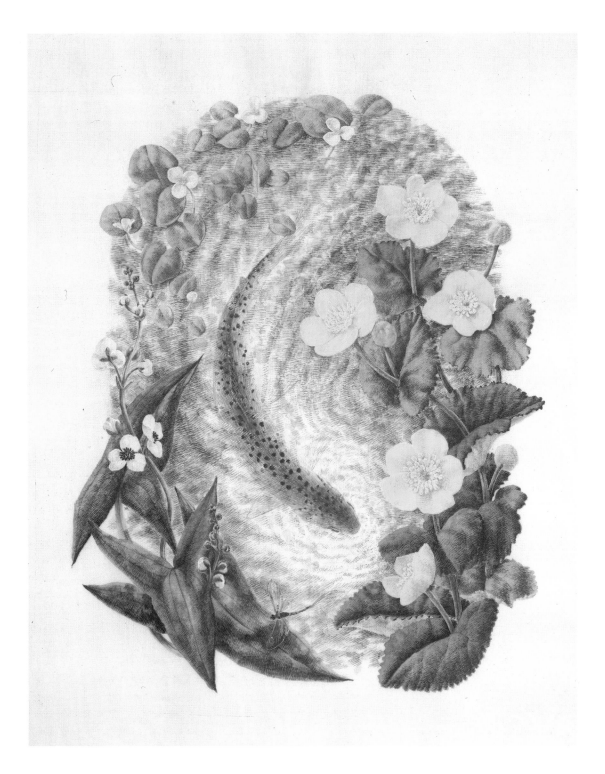

A colour mixed with white becomes a tint of that colour.

TECHNICAL TERMS

There are various technical terms used to describe colour. Colours such as red, blue, green, yellow are HUES. If, when mixing, white is added to the hue the result is a TINT; for example, red and white give pink – pink is a tint of red. Conversely, black or other neutrals mixed with a hue gives a SHADE of that HUE. In practice, when often several colours have been mixed together, the colour produced is usually referred to as a shade.

TONE or TONAL QUALITY refers to the darkness or lightness of the colours, while INTENSE colour means the actual strength of the colour – i.e. a very rich undiluted application of Vermilion as opposed to the same colour well thinned with water or another medium.

BRILLIANCE of colour is its brightness – shining, dazzling, glowing off the page.

WARM and COLD, when referring to colour, are emotive responses to the associations colours have for us. Red represents the sun and fire and therefore heat; blue is for the cold shadows of winter. However,

Three simple diagrams to show the optical illusion by which warm colours appear to advance and cool colours recede.

Opposite: The colour circle is a method of arranging colour in such a way that each colour is opposite its complementary colour and the secondary colours lie between the primary colours. It is useful to make such a chart and to keep it for reference. In the first colour circle (left) the secondary colours were made by mixing the primaries used in the circle. In the second (centre), the secondaries were made by using colours from hues other than the primary hues used in this circle. The third circle (right), was made by using transparent watercolour washes: each primary was washed over half of the circle area so that each colour blended with the two other hues to make the secondaries.

A colour mixed with black becomes a shade of that colour.

blue containing some red would be termed a warm blue, while a blue with a greenish tinge would be cool. It is said that warm colours *advance* and cool colours *recede* from the eye.

Primary, secondary and tertiary colours

PRIMARY COLOURS are red, yellow and blue; these colours cannot be reproduced by mixing.

SECONDARY COLOURS are made up of two primaries mixed together: for example, red and yellow make orange.

TERTIARY COLOURS are those made by mixing three or more colours together.

The three primaries mixed together make a neutral grey.

Complementary colour

The COMPLEMENTARY of a colour can be defined as the primary remaining after two are mixed together: for example, blue and yellow produce green – the complementary of green is therefore red. By an optical illusion one may find the exact complementary of any colour. This is obtained by gazing steadily at a colour for some minutes and then transferring one's gaze to a white surface where an after-image of the complementary colour will appear. If you choose red as the colour to stare at, the after-image should appear green.

Complementary colours when mixed together give neutral shades as each cancels out the other.

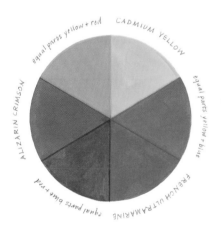

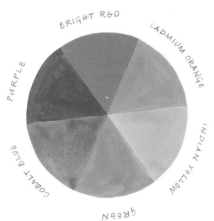

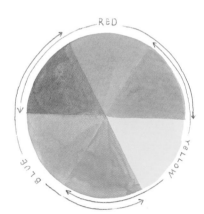

Simple diaper patterns showing counterchange and interchange, three-dimensional effects, and the grids on which the patterns are built.

LINDISFARNE

Carpet page with cross from The Book of Lindisfarne. *English (Northumbria) c. 698 AD. Ground pigments on vellum. $13\frac{1}{2} \times 9\frac{3}{4}in$ (343 × 248mm). The British Library. This beautiful carpet page has been included as an example of pattern building in its highest and most sophisticated form, and as an encouragement to those who feel they cannot draw free-hand. The patterns have been built up on a simple grid of multiples of the width of the border strips framing them. It is the careful use of colour and the rich texture of the multiple patterning that makes this form of decoration so satisfying to look at.*

Induced colour INDUCED COLOUR is the effect colours have on each other when placed together. Complementary colours painted next to each other and of the same tonal value seem to vibrate because each intensifies the other.

Colours react to each other according to the ground on which they are laid, the light in which they are viewed and the distance they are from the eye. The *same* colours used together in varied areas will also look different and vary according to the distance they are from the eye. As an example, take a fabric woven in checks of red and blue – the warp is made up of red and blue stripes and to make checks red and blue stripes are woven across this warp. The result will be red and blue squares where the blue threads cross blue warp and red threads cross red warp, but in the areas where red crosses blue and vice versa purplish checks will appear. Although the threads are still red and blue they have been broken up into small spots of colour which to the eye at a distance merge to form purple.

Local colour LOCAL COLOUR is the name given to the intrinsic colour of an object. The local colour of a cornflower is blue, of a blade of grass, green – and so on.

Reflected colour REFLECTED COLOUR is the colour objects pick up from their immediate surroundings. A white saucer placed under a green plant will reflect that green on its surface.

PIGMENTS

Chinese Vermilion is a fine colour, but difficult to obtain; it was said that the genuine pigment was reserved exclusively for the Chinese Emperor (whose edicts were written with 'The Vermilion Pencil').

From *Writing, Illuminating and Lettering* by EDWARD JOHNSTON

Colours are divided into ORGANIC and INORGANIC pigments. OR-GANIC pigments have a plant or animal origin; INORGANIC pigments come from minerals – either natural minerals known as 'earth' colours or factory produced as a chemical process. Many pigments are poisonous – some contain arsenic – so it is advisable *not* to suck one's brush; use a rag or paper tissue to remove excess colour or to reform the tip when working.

PERMANENCE OF COLOURS

Ideally, one's choice of pigments should be limited to the most perma-nent, but some less durable colours are very beautiful and are permissible in certain circumstances. Calligraphers have an advantage here in that their work in books is less likely to be subjected to light for long periods. Framed work is different and extra care should be taken that any colours used are as lightproof as possible. When accepting a commission for a framed wall-panel, it is as well to either see for oneself the position in which it will be hung, or to find out from the commissioner details of the site, particularly the amount of light to which the work will be exposed.

While it is fun to try out some of the more exotic colours available, for serious work a calligrapher needs a palette of the more permanent colours. Remember that the mediaeval painters made all their beautiful illuminations with a very restricted palette.

COLOUR TESTING

If in any doubt as to a colour's fastness to light, it is simple to test it. Paint a strip of colour on a piece of paper or vellum and place it in a book so that half the strip of colour is hidden between the pages and the other half exposed. Leave the book in a strong, natural light for three weeks. Then remove the piece of paper. If the strip is the same colour throughout, one is reassured of its fastness to light; if the strip has partially faded, it is better not to use this colour for any work which will be exposed to strong light conditions.

Colour merchants in their catalogues mark their colours according to the permanence or otherwise of the pigments. If you are not sure of a colour's permanence, ask your supplier to show you the appropriate list.

Opposite: Page with decorative borders from 15th century manuscript. Ground pigments and burnished gold on vellum. 7½ × 5in (190 × 127mm). This is a very typical filigree border of the period, with sharp pen-drawing and crisply defined tendrils. The colours are used with fine discrimination; the tiny flowers and leaves in the borders are very diversely shaped and decorated with fine hair-lines. The gold spots are well burnished and give a good play of light across the page.

in magna glia e. Quercaui
radices. Consputus e. hu
liatus e. flagellatus e. cu
cifixus e. uulneratus e. 9
temptus e. Ecce b ipes no
e. bz in eccia glia radicis pol
let. Tx. Jnagoga ipforum
circumdederut me. 9 no redoi
oi retribuetibz in mala. Consu
met one nequitia peccor 9 oi
rige iuftum. R. Judica me one
fm iuftitia mea. 9 fm innocetia
meam fr me. Consumet. Ad
laudes. 9 phor. a Jace one
et osidera qm tribulor iz elocite
exaudi me. ps. ois. a Disce
ne caufam mea one ab hoie i
iquo 9 poloso eripe me. ps Judi
ca. a Um tribularer cla
maui ao oim oe uentre infer
exaudiunt me. p. Os os. a
Ne uim patior responde p
me qz nescio qo oicam inimici
meis. ps. Ego oixi. a Oixe
runt impy oppmamus uiz iu
tum qm oitus est opibz mis. p.
Laudate. ao bn. a Ante
oiem festum pasce sciens ibs q
uenit eius hora cum oilexisset
fuos infinem oilexit eos. oro.

Ooips sepitne os ta
nob ita oominice pa
fioni sacrameta pagere. ut
moul getia papere meream
p. eunde. Ad uespas. a Jnio
mum oin. ps. Letatus cu ir.
at. ps. ao. or. at. Potestate
habeo ponendi aiam mea q ite
Tua nos fumech ca. or
mia os. et ab omi fub
reptioe uetustatis ce puget
et capaces scie nouitatis ef
ficiat. p. Hz. uij. S.mo. s
Egimur abrosy. e. l. i
qr xps pecca mia por
tat. 9 pro nob oolet. Doles
q one. no tua bz mia uulna
no tua morte bz mia infir
mitate. Et nos stimauimus
te ee in ooloribz. cu tu no
ppt te bz p me ooleres. Jn fi
matus es bz ippt pecca mia
No quia tibi illa infirmita
erat ce pie assupta bz p me
suscepta. qr in prodeiat. ut
curoitio pacis mie eet inte
9 liuore tuo uulnia mia fana
res. Ri Oculi sunt ao ifu
me lingua oolosa 9 fmonibus
ooy circumdederut me. peo ut

WATERCOLOURS Pigments prepared for watercolours have to be very finely ground and mixed with the smallest amount of binding medium so that they are instantly soluble in water.

Binding media vary and may include gum arabic, gum tragacanth, or fish glue with the addition of glycerine, crystallised sugar – even honey and syrup. Glycerine and any of the sugar additives increase the solubility of the colours. Too much glycerine leads to a stickiness which makes handling the colour difficult and causes shine on the surface of the work.

Experiment with your chosen colours by mixing and superimposing them in varying combinations to discover their qualities.

SELECTING
WATERCOLOURS
White

CHINESE white is the best white pigment for use as a watercolour. It is a very dense variety of oxide of zinc and covers well. It is permanent to light and does not darken.

TITANIUM white is also a strong covering agent and, as far as is known, harmless.

CREMNITZ white, made from white lead, should not be used as it may turn brown when exposed to the atmosphere.

Yellow LEMON yellow and NAPLES yellow are the lightest colours next to white.

YELLOW OCHRE, RAW SIENNA and Lemon yellow are the most permanent yellow pigments, but CADMIUM yellows (except Cadmium lemon), Naples yellow, INDIAN yellow and AUREOLIN are all reasonably durable. In watercolour, Naples yellow is a combination of Zinc white, Venetian red and Cadmium yellow and I find it a very valuable colour to have.

Orange Although theoretically one can make a wide range of orange colours from different reds and yellows, I still prefer to have CADMIUM orange available, both for use on its own and for mixing with other colours.

Red VERMILION has a traditional place in a calligrapher's palette. However, Vermilion should not be used if the work is to be exposed to direct sunlight, as it has a tendency to blacken under these circumstances. Neither should it be used against a 'copper' colour, such as Emerald green, as this will also cause it to blacken where the colours touch.

SCARLET VERMILION tends towards orange when compared with true Vermilion. It is not only useful on its own, it may also be added to pure Vermilion, if a more fiery red is required.

Vermilions vary a great deal in quality, especially in the Chinese

stick form; but the best of these are very good indeed, if one can obtain them.

CADMIUM red may be substituted for Vermilion, but it has the same tendency to blacken on contact with Emerald green.

VENETIAN red and INDIAN red are good permanent earths which I use a great deal.

For a red with a purplish tone, try Alizarin crimson, Permanent Rose, or Rose Doré, although none are reliably permanent. Genuine Rose Madder is a beautiful but impermanent colour which might be tried within the confines of a book.

Blue GENUINE ULTRAMARINE made from ground lapis-lazuli is the brilliant blue used by mediaeval scribes in their illuminated manuscripts. It is still possible to obtain this colour today, but it is difficult to use, very expensive and not suitable for beginners.

FRENCH ULTRAMARINE is the substitute for the genuine variety. It is resistant to light, but may discolour in the presence of acids. I do not use Ultramarine as a pure colour, but add it to other blues such as Cobalt and Cerulean.

COBALT blue is lightproof, unaffected by other colours and may be mixed easily with other blues. A touch of Ultramarine will give it a more purple tone, a little Cerulean will incline it to green. Cobalt blue is my favourite blue.

CERULEAN blue is a very durable colour, a greenish-blue and quite invaluable, not so much for use on its own, but for mixing with other blues and colours. Cerulean with Lemon yellow gives an excellent Turquoise.

PRUSSIAN blue is a strong colour and rarely, if ever, used on its own. By adding a touch to other blues, it will strengthen and enliven

the colour, and with yellows makes strong greens. When using with other blues, take care that it does not dominate them. Prussian blue should be used with discretion.

One can make blue-blacks and brownish-blacks by mixing Prussian blue with the red earth colours. When mixed with a zinc white, such as Chinese white, it has a strange characteristic of fading in strong light; but it will regain its strength if kept in the dark for some weeks.

CYANINE blue is a mixture of Prussian blue and Cobalt.

INDIGO, a dark grey-blue, is a vegetable blue coming from the Indigo plant, but is not very reliable.

Green Pure EMERALD green is highly poisonous and not compatible with other colours, such as Cadmium yellow, Vermilion or Ultramarine. As the last two pigments are much used by scribes, it is best to leave this rather tricky colour alone.

VIRIDIAN, a transparent copper green, is very permanent, safe with other colours and is not poisonous. The addition of a little Chinese white to give it body will produce a good opaque green not unlike Emerald green.

COBALT green is not quite as durable as Viridian and as a colour lacks strength – but, again, it is not unlike the Emerald colour one sees in old manuscripts and a little white will give it body.

TERRE VERTE, as its name suggests, is an earth colour; it is useful both as a green and for underpainting – for which it was much used in the Middle Ages.

Except for these greens, I make my own from various colours. Most of the greens sold such as Hookers green, Sap green, and Prussian green are not so durable, and are not very pleasant colours.

Brown, Grey, Black BURNT SIENNA, RAW UMBER, BURNT UMBER and INDIAN red are all brown earths and good, safe colours from which to mix browns and greys.

DAVY'S grey is made from a special variety of slate; it has a light soft effect and is good for mixing with colours.

PAYNE'S grey is prepared from a mixture of Ultramarine, Prussian blue, Alizarin crimson and Lamp black. It is not as permanent as Davy's grey.

IVORY black and LAMP black are greatly used in watercolour work and are both durable.

PERSIAN black has a lovely soft quality, if you can obtain it.

Apart from Persian black, I prefer to mix my own.

Purple I do not use purple or violet to any extent and usually mix them for myself, but for a ready-mixed purple keep WINSOR violet in reserve. It is a reliable colour, as is COBALT violet, when it is obtainable.

MIXING COLOURS

When you have assembled a palette of your chosen colours and if you have no experience of painting – or very little – practise mixing your colours together to find their maximum range:

Mixing Lemon yellow and Cerulean blue to show their possible colour range.

1 Take a sheet of white paper and a yellow and a blue – Lemon yellow and Cerulean blue, for instance.

2 First paint a small rectangle of yellow as pure colour.

3 Then add a small quantity of blue to the yellow in your palette – only a brushful or so at a time – and it will start to green the yellow. Paint this in another rectangle next to the first.

4 Continue in this way, adding a little blue to the previous mixture, until you find that you are painting practically pure blue.

5 Then paint the final rectangle in the pure blue colour you have been using to mix with the yellow.

You will now have some idea of the possibilities of the two colours. Try other primaries in the same way: Vermilion and yellow together to make orange or orange-reds; Alizarin crimson and Ultramarine to give a range of purples and blue reds.

When you have investigated the range of your primaries in this fashion, you will begin to realise the great variety of colours that you can make from three primary hues.

Now try adding white to the primaries, gradually lightening the hue until you have its range of tints.

By adding black in a similar way to red, yellow or blue, you will get a corresponding variety of shades.

Making greys from blues and browns
A *Cobalt blue and Venetian red*
B *Ultramarine and Indian red*
C *Cerulean blue and Venetian red*

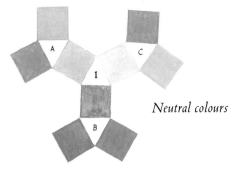

Neutral colours Combinations of the three primaries give a neutral colour, as do combinations of the complementary colours. For greys, a higher proportion of blue is needed when mixing the colour; for browns more red; for fawns and golden neutrals, more yellow.

Cobalt blue with Venetian or Indian red makes a good warm grey; by using Cerulean blue with the same reds, you will get a cooler grey. Try out any blues you have with various browns or reddish-browns

31

and find out the range of neutral colours you can make with them, and the proportions of each colour needed to make these neutrals. By adding various yellows and orange to these combinations of colour, you can make the grey cooler and greener or more golden.

Green Greens may be made in great variety with blues and yellows. The addition of red will grey the green or a touch of black or grey. Cerulean blue with orange will make an olive green which may be deepened with a little red or black.

Making greens
D *Cobalt blue and Indian yellow*
E *Ultramarine and Lemon yellow*
F *Cerulean blue and Cadmium orange*

Making purples and mauves
G *Cobalt blue and Permanent Rose*
H *Ultramarine and Alizarin Crimson*
I *Cerulean blue and Rose Madder*

Purple Not all reds and blues will make purple, if they are mixed together. To make a good purple, you need a warm, crimson red with a blue tending to red. Alizarin crimson and Ultramarine make a good purple – but Vermilion and Cobalt or Cerulean will only make a brownish shade. This is because Vermilion has no blue in it and both the blues tend towards green. Rose Madder with Cerulean can give a charming lilac, but the proportions of each colour have to be carefully adjusted.

Blue Cobalt blue with a little Ultramarine and Cerulean mixed with it gives a greater depth of colour than if it is used alone. This mixed blue is most useful for heraldic work and will take a touch of Chinese white to give it more body. It looks very well with Vermilion or gold. All sorts of blues may be mixed and are often better than the hue used alone: French Ultramarine is a hard, crude colour straight from the pan or tube; Cerulean is vivid and harsh and Cobalt rather thin.

Red With reds, more care should be taken when mixing them together. Nothing will give greater fire than purest Vermilion used alone – admixtures will only dull it. Alizarin crimson added to Vermilion darkens it without losing its fiery quality and is useful for modelling in heraldry.

Keep all your sheets of experimental mixing of colours. Make notes beside each trial of the colours used: they will make a valuable reference chart when working on a painting.

It is a good exercise to mix colours in your head when you are not painting. When I see any colour that attracts me, I begin automatically to select the colours and quantity of each colour I should need to imitate it.

It is also a good practice to try to remember accurately the colours you have seen so that they may be reproduced correctly at a later date. This is much more difficult than it sounds, especially with subtle colours. With a tree, bird, landscape, or trick of light, you either have to make colour sketches on the spot, or secure it in your memory to reproduce at will in your studio later.

Knowing the right colours to choose to make the particular shade or tint you require, and the right proportions of each colour to mix together to achieve this aim, is an important facet of learning to paint.

GOUACHE

WENDY WESTOVER

Two headpieces from the RNLI Memorial Book 1973. Watercolours and gouache on vellum. Each 5 × 5in (127 × 127mm); ovals 2in (51mm) across. Royal National Lifeboat Institution. A delightful combination of straight miniature painting in the oval medallion and imaginative use of natural plant studies as settings. The paintings for this book achieve a very high standard and the borders show a great variety of subjects skilfully handled.

GOUACHE COLOURS, or body colours, are prepared pigments with the addition of white fuller's earth, such as clay or barite. They give excellent results when used on coloured and textured grounds.

The best of these preparations, under the name of Designers' gouache, are obtainable in a fine range of colours, similar to watercolours, but not always called by the same names. However, Lemon yellow, Cadmium yellow, Cadmium orange, Alizarin crimson, Prussian blue, Cobalt blue, Ultramarine, Cerulean blue, Viridian, Naples yellow, and various 'earth' colours should be available and a range of greys and black. Besides these familiar colours, there are many more: colour mer-

ALDEBURGH

MUMBLES

SHEILA WATERS

Title page from Under Milkwood *by Dylan Thomas. Watercolours and gouache on handmade paper. $17\frac{1}{2} \times 10\frac{1}{2}$in (444 × 267mm). Commissioned by Edward Hornby. The rich colouring of this intricately patterned piece of work is cleverly based on the colour sequence of the spectrum. Through the bands of letters, the vibrant colours are graduated by means of the imaginative figures and involved patterns reminiscent of such early manuscripts as* The Book of Durrow *and* The Book of Lindisfarne.

chants have their own names for their mixtures – such as Bengal Rose, Marigold yellow, Parma violet, Cyprus green, Mistletoe green, etc.

Start off with a small selection of colours that you think will prove useful; add gradually others that you find necessary for a particular piece of work.

Although gouache colours may be mixed and used in the same way as watercolours, their qualities are different. For writing in colour and for painted letters they have a substance lacking in watercolour; and for heraldry and other 'flat' work, they are often the best type of colour to use. Gouache colours have an opaqueness and covering power ideal for certain types of painting such as flat washes; if the colour is used at the right consistency, it will dry with a matt surface with no trace of brush marks. Gouache may be used in thin washes, but it will still retain its opaque quality to a certain extent and, however thinly used, will lack the transparency of pure watercolour. When thinned for writing, it should still have enough substance to dry an even colour without showing the penstrokes.

IDA HENSTOCK MVO
Decorated initial letter from Service Book. Powder colours, raised and burnished gold on vellum. Portsmouth Cathedral. This initial from one of the service books of Portsmouth Cathedral is finely drawn, painted and gilded. Ida Henstock's work is a continuation of the traditional decoration of earlier manuscripts. She skilfully adapted the forms of the plants, animals and birds of the Hampshire countryside to fill with intricate patterns her gilded capitals and margins.

POWDER COLOURS

Artists' pigments (dry ground) are the nearest substitute to grinding one's own colour in imitation of the mediaeval illuminator. The same range of colours as for watercolours is available.

These powdered colours are pure pigment and will need the addition of a suitable medium and binding agent before use; but as you will have full control over your mixtures, you can experiment with different quantities of these agents to try and find the consistency and substance combined with fluidity which is ideal for your own type of painting.

Dry ground pigments, correctly prepared, furnish you with the purest colours obtainable, but because much care is needed to prepare them, it is obviously easier to use colours already made up in tube or pan form.

Dry ground pigments are suitable for flat work, such as decorative initials or heraldry, where particularly brilliant colour is desirable. They are very traditional, and by using a tried medium such as egg, the colour should remain as brilliant as in mediaeval illuminated manuscripts which have the same intensity of colour now as they had when they were painted hundreds of years ago.

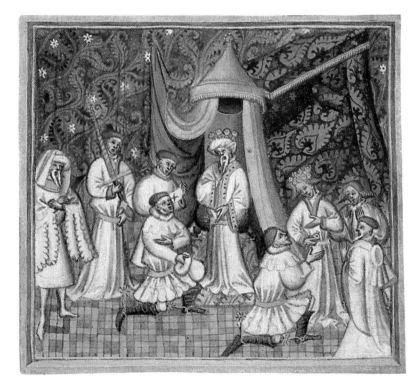

Miniature from Life of St Edmund. *English manuscript completed after 1433. Dry ground pigments on vellum.* $9\frac{7}{8} \times 6\frac{11}{16}$ *in (250 × 170mm) page size. The British Library. The painter draws attention to his well-grouped, finely drawn figures by arranging them clad in light tones against coloured and textured backgrounds made up of intricate and detailed patterns.*

Opposite: MARIE ANGEL
The Caterpillar *by Christina Rossetti. Watercolours on vellum.* $8 \times 7\frac{1}{2}$ *in (203 × 190mm). Commissioned by the Victoria and Albert Museum. This short poem was arranged on the double-page spread with the emphasis on the word 'CATERPILLAR'; the letters were stepped downwards to create a feeling of undulation to which the caterpillar itself also contributes. The curve of the strawberry leaf and the caterpillar's head carry the eye down and across the page towards the final capitals and the peacock butterfly. Abbreviations, such as the ampersand, and the fusing of certain letters, such as the T and E in 'BUTTERFLY', often help to keep capitals within the text column.*

DESIGN

. . . all that concerns special treatment of the thing, all that concerns variety, emphasis or illumination – also concerns, but more subtly, all the ordinary letters and parts of a manuscript : SO THAT EVEN IN HIS INDIVIDUAL PEN‑STROKES *the penman may be in sympathy with the words that he is writing.*

From *Formal Penmanship* by EDWARD JOHNSTON

A calligrapher's design begins with the first conception of the book or broadsheet. The interpretation of the chosen text is of prime import‑ ance and one should strive to convey sympathy with the author through the writing and decoration of the work.

PRIMARY DESIGN

For a book, all the groundwork must be planned in advance. You must know page size and number of pages; how many chapter head‑ ings; the type of hand to be used for the text; whether or not there will be decorative initials – and so on.

PAGE DESIGN

In planning the page design, you must consider the spaces needed for paintings, decorative capitals, headings, etc. The proportions of the page size and text column will play a large part in determining these.

37

Below left: MARIE ANGEL

Australian Wrens from Exotic Birds, *an anthology commissioned by Richard Harrison. $17\frac{1}{2} \times 11\frac{1}{10}$in (444 × 282mm). Watercolours on vellum. This page from a large-sized manuscript book is an example of the type of design possible on an extended page area. The weight of the Foundational hand used for the text provides a steady balance to the pages so that a fluid, flowing design of birds and plants may be used within the framework of the text column.*

Below right: MARIE ANGEL

Lizard. Text by Maximus of Tyre. Watercolours on vellum. $5\frac{1}{2} \times 3\frac{3}{4}$in (140 × 95mm). Designed for reproduction as a card and calendar for The Green Tiger Press. In this composition, the drawing of the lizard and plants was made first and the quotation fitted round the finished painting, although this is contrary to my usual practice.

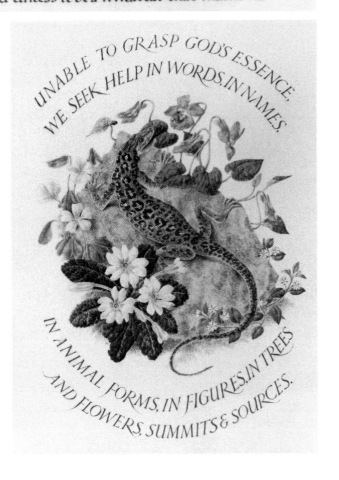

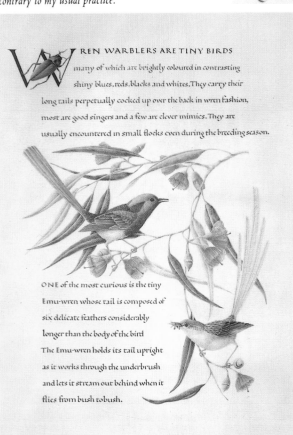

MARIE ANGEL
Wheatear from Nature in Downland *by W H Hudson. Watercolours on vellum. 4¼ × 6in (108 × 152mm). A natural study of a bird in its true environment showing the camouflage effect of the bird's colouring among the flints of the Downs.*

A large page size will obviously give more room for a bold and vigorous design than a small one. The hand used for the written text will exert its influence, too: a rich Gothic hand or a good solid Foundational will require a different sort of drawing from a light Italic.

However, you should not necessarily aim for an even weight across the page: very fine visual effects may be had with asymmetrical arrangements where text, decoration and space are well balanced. The page must not appear top-heavy; nor should the textual composition seem to slip through the foot of the page. It is important to train one's eye

MARIE ANGEL *(paintings)*
DOROTHY MAHONEY *(calligraphy)*
Prayers from the Ark *by Carmen Bernos de Casztold. Manuscript book. Watercolours on vellum. 15 × 10¾in (381 × 273mm). In the painting facing this page of the manuscript (reproduced as the frontispiece to this book), the animals were carefully arranged in diminishing size and curving to the right to lead the eye round to the poem again and upwards to the initial capital with the dove flying across to Noah.*

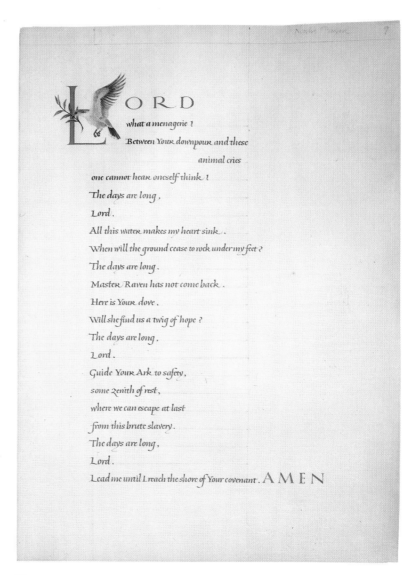

39

to balance the vital components of the page in symmetrical or asymmetrical composition with reference to space, text, and decorative work.

SPACE

MARIE ANGEL
Jenny Wren by Walter de la Mare. Watercolours, gouache and shell gold on handmade paper; bound with boards covered in an Ingres paper, ruled with black and shell gold lines and letters in shell gold. $6\frac{1}{10} \times 4\frac{4}{5}in$ ($154 \times 125mm$). This little manuscript book was made as a birthday gift for my mother, who was particularly fond of wrens. The lettering was written in a blue-grey made from gouache colours diluted to the right consistency. The drawing was painted in a similar colour using watercolours, with the bird in various browns and fawns. Details were then picked out in shell gold, some of which were burnished.

Marginal space has a great effect on the page. The proportions of the text in relation to these spaces provides the underlying rhythm and pattern of the book. The counterspaces and interspaces of headings and decorative capitals must also be considered, as must the spaces reserved for illustrations.

The spaces that are left undecorated are just as important to the design of the page as the weight of lettering or drawing, so the final composition of a painting within the text column must be designed in relation to the whole page.

In designing a book, the eye must travel round the page rather than slide out through the margins. The composition must be designed to take the eye into the centre of the book. A painter may compose a picture to hang on a wall of a leaping tiger. For a framed painting,

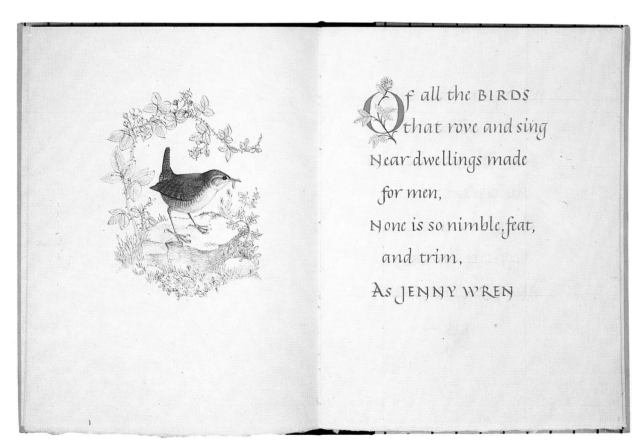

it does not matter very much whether the tiger is leaping to right or left; but in a book, it is usually better for the tiger to leap towards the centre of the book to draw the reader's eye into the pages and text.

CAPITALS If a miniature painting is within the text on the same page as a decorated capital, the size, shape, decoration and position of that capital will affect the painting and they should be linked in some way – either by colour, form, rhythm or line.

With letters having a strong diagonal such as R, W, or K, this diagonal repeated again in the underlying structure of the drawing will strengthen the harmony of the page. With round letters, curved forms and flowing lines carry through the rhythmic feeling into the painting. Of course, these lines need not be actual lines drawn on the page, but invisible lines running round forms or linking one subject with another or bonding together two or more compositions on the same page. However, every page presents different problems and there will be times when a strong diagonal design through a round capital will be just what is wanted.

Every page and every painting is unique and individual to the person creating the images and it is impossible to give hard and fast rules to govern designing.

COMPOSITION Lines of writing give horizontal or near horizontal ribbons of texture across the page. This is the easiest way for the eye to assimilate the text. A design made up of evenly sized shapes and forms carefully spaced horizontally to give an even balance between form and background will have the same underlying calm as the written text. Think of strings of clouds across an evening sky, in line upon line, all much the same size but varying slightly in shape and all having horizontal bases: the whole will have an appearance of great tranquillity.

A quiet, balanced design may also be achieved by arranging even shapes in vertical lines and vertical forms, such as the standing human figure, trees, and tall buildings.

Tension and vigour may be supplied to a composition made up of horizontal or vertical lines and shapes by tilting the lines or masses so that they are no longer parallel to the frame of the design. Zig-zag lines, sharply opposing lines or masses, short broken lines, all create tension by stopping the eye running smoothly round the composition.

Undulating lines and masses and curved forms may give movement for a calmer mood; or, if used in a stronger way, they can create the incredible tension and vigorous movement visible in some of Van Gogh's drawings and paintings.

41

BALCHAND

The Emperor Shah Jahan. Mughal miniature.
c. 1630. Gouache on paper. 14½ × 10in
(370 × 250mm) page size; 8¾ × 5¾in
(220 × 141mm) picture. Victoria and Albert
Museum. This very beautiful painting, with the
standing figure immobile against the serene turquoise,
conveys a feeling of peaceful calm, accentuated by
the graceful curves of the two Birds of Paradise
(symbolising 'Happy Augury') flying above him.

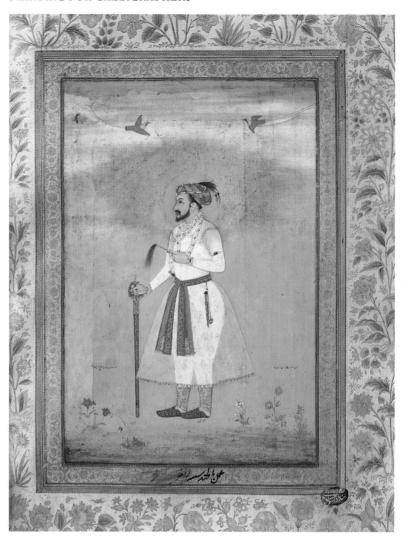

The triangle in the structure of a design always gives strength and stability and is possibly the best basic structure to use.

Focal point Most compositions need a focal point about which the rhythmic lines circulate, and to which strong diagonals lead, in such a way that the eye, after running round the rest of the painting, returns to it again and again. Unity of the composition is aided by a good focal point around which the rest of the design may be built.

One of the finest ways of learning how to compose a picture is to look at paintings in galleries, museums and libraries. Study them and try to see why one painting has great force and impact while another is

42

SIMON BENING

Calendar illustration attributed to Simon Bening.
Bruges, c. 1530. Dry ground pigments on vellum.
12⅛ × 8¼in (310 × 210mm). The British Library.
This painting of a boar hunting group illustrates
December. The superlative painting technique and
very high standard of draughtsmanship in this
miniature reveal a close observation of nature: the
trees, for example, are all individual — nothing
stereotype here. The composition is unusual with the
oak tree in the centre foreground subtly carrying the
eye into the distant landscape with its enchanting
fortified town on the hill-top. In the middle distance,
the houses are blended into the tones of hills and wood
so that, while they add interest, they do not interrupt
the harmony of the whole. Another interesting feature
is the number of V-shapes (or inverted triangles)
either stated or as 'invisible lines' appearing in the
composition: in the one composed of the hunters and
dogs in the foreground, the white dogs deliberately
accentuate the shape. Note the similar wedge-shape of
the wood in the middle distance and the line of the
tree-tops, framing the little town on its summit as a
focal point.

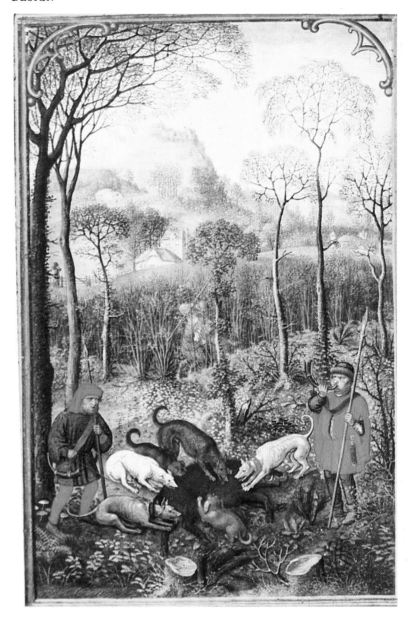

tranquil and calm; why one has been painted in sharp colour contrasts and another in a low, harmonious tone throughout. Try to analyse why the painter placed his shapes and forms in his composition as he did and what effect he has achieved by so doing. By looking at paintings in this manner you should learn a great deal to help you in your own designs.

43

TONES

Tonal quality is as important in a design as form and structure.

All tones are related to an imagined scale of white (or lightest) to black (or darkest) tone. These values are not related to light and shade, but only to colour and the entire visual impression considered as a pattern of masses of varying degrees of lightness or darkness. For example, a white object in deep shade will often be darker in tone than a dark object standing in a strong light.

Tone value also relates to the colour harmony of the picture – a single colour may be out of key with the rest of the painting. This tonal dissonance may be used with purpose to create a particular mood.

A good arrangement of tone values is an important part of pictorial design. Sympathetic tone values are those in the middle range – lights low in tone and the darks high. When contrasts are very marked, tones become more vibrant and intense.

If your main subject is to be sharply defined in the foreground, your background should be softer and lighter in tone to give recession.

BROADSHEETS AND
BROADSIDES

When designing broadsheets and broadsides, the same preliminary work must be done as for a book. All measurements, text, hand, etc. should be decided upon before beginning work. It also is important to know where the broadsheet or broadside will be placed, and what light conditions prevail there, before deciding on colour and design.

Formal broadsides – such as memorial notices, heraldic panels, presentation addresses, award certificates and panels – should be kept to the proportions of the book page; but the side margins should be equal and the contents of the panel are usually symmetrically arranged.

Broadsheets tend to be much larger than book pages and should therefore be treated more broadly. While books are meant to be held in the hand and examined closely, a broadsheet on a wall has to attract the attention of the viewer from a distance; so a bolder approach, with simple shapes and forms, combined with arresting colour, is more likely to succeed. This is particularly true if the panel is to be hung in a busy place where passers-by hurry to-and-fro and anything insignificant would fade into the background rather than catch the eye. Dark churches and dimly lighted church porches are other sites where panels need to be designed to stand out well from their surroundings.

Heraldry is often used in wall panels. The well defined and easily readable shapes of shields and charges, the crisp mantling, all painted in brilliant pure colour, sometimes with the addition of burnished gold, combine to make a rich and decorative design which looks well in most situations.

Decorative broadsheets may be designed more like an ordinary

framed painting. The amount of text used is often minimal – sometimes
only a single line – so that greater freedom is given to the designer
in incorporating the letters with the painting which together are to ex-
press the mood of the text. Strict margins may be ignored and the
text regarded as a texture within the painting.

By perfect placing, the words should retain all their significance even
if the writing is small in relation to the illustration. In oriental paintings,

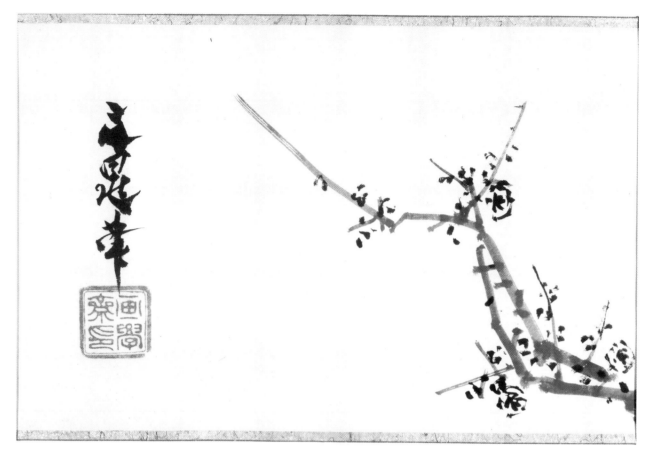

TANI·BUNCHO (1763-1840)
Plum bough, with the artist's signature and seal. End portion of an ink-painted hand-scroll. Japan, c. 1820. The British Museum. This very expressive and dynamic brush-painting of a flowering plum bough, in itself a beautiful composition, is perfectly balanced by the vibrant calligraphy of the signature which is boldly poised above the square red seal of the artist. Note the superb positioning of the drawing and signature in relation to each other and the blank areas of paper that are so important to the design.

for example, a few characters exquisitely written and perfectly positioned set off a painting in such a way that if they were removed the whole structure and design of the painting would be destroyed. The most important aspect of composition is this exact positioning of every component within the framework of the design.

Many broadsheets and wall-panels now made by calligraphers are created with such freedom that they are nearer to fine art than any other calligraphic production. Unfettered by the rules governing the page, and produced by the calligrapher under direct inspiration from literature, music, nature, wall panels can express the individual characteristics of the calligrapher in a marked fashion.

With this freedom, in some cases, even legibility of the written words has been thrown to the winds. I feel this is a mistake — why use letter forms if they cannot be read? Edward Johnston wrote that 'the prime purpose of writing is to be read.' If freedom of expression is to take over from craftsmanship so that the calligrapher becomes, in effect, a

painter, it would surely be better for the scribe to abandon writing and use the brush or pen to make abstract calligraphic shapes, which would be nothing more than decorative, providing texture, weight, and form, in the painted composition.

EPHEMERA Ephemera is the term used to cover a wide range of small items, such

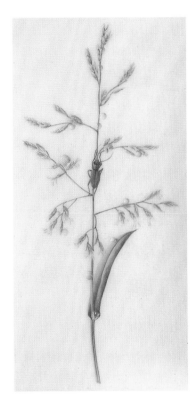

MARIE ANGEL
Grass-head with Beetle. $3\frac{3}{4} \times 1\frac{7}{10}$ *in*
(95 × 42mm). Watercolours on vellum. Made
as a small, personal greetings card, this is
a straightforward drawing from nature.

MARIE ANGEL
Liber Minimus I. $1\frac{4}{5} \times 8\frac{1}{4}$ *in* (45 × 210mm).
Liber Minimus II. *2 × 9in (51 × 229mm) open.*
These gift books were made very simply of thin
vellum folded into stiffer vellum covers. A small
object crudely or carelessly painted will look shoddy:
the smaller the object or page, the greater is the
precision and care needed even in small pieces of
ephemera such as these.

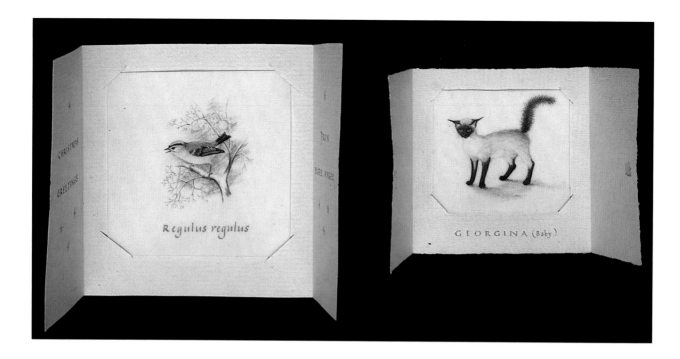

as greetings cards, bookplates, logos, decorative headings, small gifts, etc. They are often of a personal nature or have an informal approach to calligraphy and miniature work.

COMPOSITION METHODS

I read the text through several times and try to decide which parts to illustrate, bearing in mind the need to interpret the intentions of the author, and that each incident chosen must make a good picture which satisfies one's own creative talent. I prefer to think about my work for a long time in advance so that a lot of the preparation, such as research on the subject – thinking of different ways of presenting it – colour schemes – compositions – and so on, may be stored up in my mind before I start work.

Unless the composition is clear in my mind, I make a number of small sketches, quite roughly done.

If letter forms are to be incorporated as part of the design, I always arrange these first; I think of them as a strong framework on which to build up my composition. These letters are most often only sketched in skeleton form and are not painted at first, but usually left until last so that the colour of the letters may exactly complement or contrast with the design.

I next assemble in my mind or on paper all the various things that are essential to the picture. There may be several things mentioned in

Above: MARIE ANGEL
Regulus regulus. $2\frac{1}{4} \times 2\frac{1}{4}in$ ($57 \times 57mm$).
Greetings card.
'Georgina.' $1\frac{1}{2} \times 1\frac{3}{4}in$ ($38 \times 44mm$).
Greetings card.
Two further examples of ephemera made as personal gifts. Both paintings are on vellum and slipped into paper covers. In very small items such as these, the lettering should be kept in scale: inscriptions should be written with a narrow nib or crow quill.

MARIE ANGEL
Feathers. Watercolours on vellum.
2¾ × 1¾in (70 × 44mm). In painting
feathers which are composed of different
colours, the same technique is used as
markings in fur (see pages 61–5). These
feathers were painted from real ones and are
about life-size.

the text which, because of their importance, must be featured in the illustration. This is the most difficult part of composition – to put together all the component parts to make a cohesive whole. It is worthwhile spending a lot of time on this: I have often spent a week or more on one small cypher.

Never think of it as a waste of time. The amount of thought before starting painting may save one from having to discard an illustration – and worse still – the vellum pages already written, because the composition is not quite right.

I usually trace off the silhouette of the main subject and anything else which needs exact positioning. But I prefer to do any careful drawing on the final surface rather than tracing off, which I think has a deadening effect on the drawing. Backgrounds and secondary matter I draw on the vellum or paper as I go along if I need to.

I use tracing paper or layout paper to assemble the component parts of the design and work through the transparent sheets all the time – trying out ideas over the written text or letters on the page. The design may then be adapted as it is worked over and it allows me to have second or even third thoughts.

When I work in this way, I often have layers of tracing paper with different ideas sketched on to them, quite roughly, so that by moving them around and placing one version over another it is possible to add

MARIE ANGEL
Initials C D with Lemurs and Cricket.
Watercolours on vellum. 3 × 3in (76 × 76mm).
This cypher was designed for the Silver Wedding
anniversary of Charles and Dorothy Mahoney. The
initials were simply interlaced and the two lemurs
arranged within them in a natural fashion. The long,
decorative tails play a large part in the composition,
echoing the rounded forms of the C and D.

MARIE ANGEL
White Horse.
Illustration from Bird,
Beast and Flower.
Watercolours on vellum.
$6\frac{1}{4} \times 4\frac{3}{4}$ *(160 × 121mm).*
This painting was an illustration to a poem and had to suggest the sultry heat of August as well as including the horse in the shade of a sycamore tree. To achieve this, the tree and foreground plant were painted in deep, cool greens and blues and the horse is silhouetted against the light, warm gold of a cornfield.

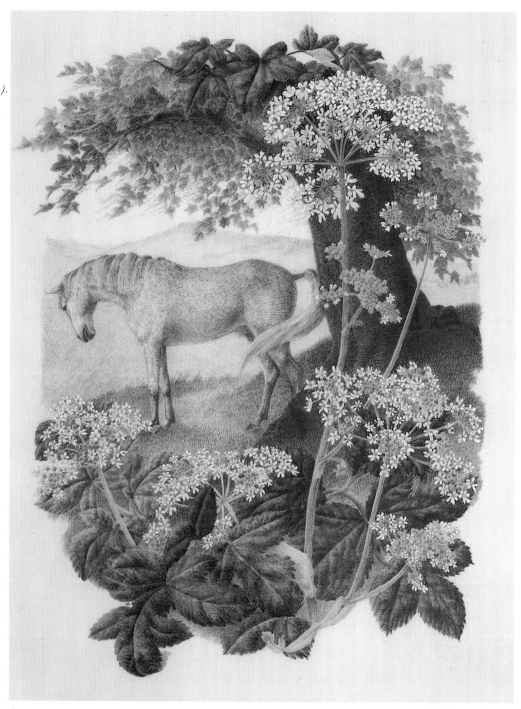

This working tracing of the illustration opposite shows my method of using paper to work out the design before committing it to paper or vellum.

MARIE ANGEL
Abyssinian cat with initials. Watercolours on vellum. 2 × 2in (51 × 51mm). Private commission. Preliminary sketches show tentative arrangement of capital letters and cat; in the final cypher, by placing the letters diagonally, there was more room for the cat to sit naturally and the curve of his tail echoes the tails of the S's.

to, or take away, parts of the composition, or to amalgamate two or three different attempts to make the final version, and to visualise clearly how my ideas will work out on the actual page.

Unless you are very sure of your drawing, it is better to use a sheet of tracing paper big enough to cover the double-page spread or broadside. You will then be able to see all the time how the drawing and decoration are going to affect the pages as a whole.

Draw the main subject onto the tracing paper; make sure it is correctly positioned in relation to the lettering. One or two registration marks on the tracing paper will help reposition it later if this is necessary. Then place another sheet of tracing paper over the first one and start to add whatever else is to be in the composition. By using a second sheet of tracing, one can discard it time after time, if the composition does not work out, while keeping the main subject in position. Separate items may be traced onto smaller pieces of tracing paper which can then be moved about around the composition until the best place for them is found. Keep all your tracings until the work is completed so that if an accident occurs and the work is spoilt you can start again with the least loss of time.

Tracing paper is also very useful for trying out colour. If you are not sure that a particular colour will be suitable for your composition, or if you think a change of colour will improve part of your design, the new colour may be painted in the appropriate places on the tracing paper laid over the illustration. In this way, any number of colour changes may be tried out; but if in the end you decide that the original one should stand, your painting is undamaged by scraping out and much time has been saved.

This method of experimenting with colours through a transparent sheet allows you to see the effect of a colour against the completed section of the painting. It will also show you the effects of induced colour, where certain colours change when they are placed next to each other.

When the essential elements in the text which must be incorporated in the painting are suitably composed, not only with each other but with the rest of the page design, start to add any background or other objects which are necessary or will add to the fulfilment of your creative feeling towards the painting.

DRAWING

Unless you are content to use geometrical shapes which may be produced by mechanical means, or are prepared to splash abstract brush marks straight on to your paper or vellum, a drawing of some sort is necessary before you start to paint.

So many people would like to draw and paint, but have no confidence in their ability to do so. This desire to create is more important than manual dexterity or technical ability.

Drawing, like calligraphy, needs plenty of practice. To draw well, there has to be a liaison between hand, eye, and mind. The eye observes, the mind selects and guides the hand to put it down on paper, and practice sharpens these faculties. Some people have the ability to draw, but fail to make a good drawing through lack of observation; but it is quite possible to train yourself to see more and to appreciate the multiplicity of forms and colours in the world around you by looking more closely at objects and making notes in your mind of what you observe.

To draw or paint anything well, you have to understand the subject you are attempting to portray and its underlying structure.

Study the skeletons of birds and beasts in natural history museums. Watch birds and study their movements: how they close their wings

MARIE ANGEL
Toad and strawberry plant. Illustration from Cottage Flowers *(Pelham). Watercolours and pencil on Green's handmade paper. $3\frac{3}{4} \times 5\frac{3}{4}in$ ($95 \times 146mm$). This pencil drawing of a strawberry plant was not intended to be coloured, but it is the same sort of careful outline drawing I would make before painting a plant.*

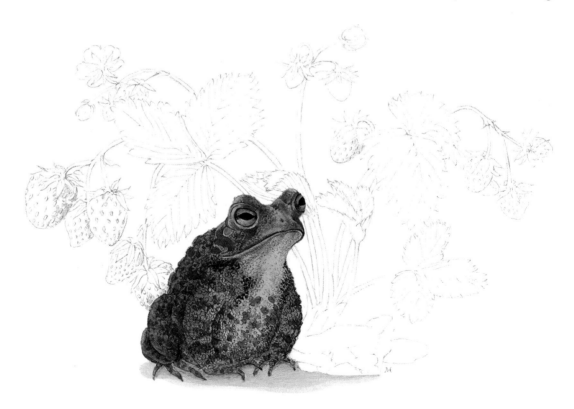

MARIE ANGEL
*Linnet on thistles. Illustration
from* Bird, Beast and
Flower. *Watercolours on
vellum.* $6\frac{1}{2} \times 5in$
*($165 \times 127mm$). This
painting shows the linnet in a
very characteristic pose as it
pulls at the seeds on the thistle
head.*

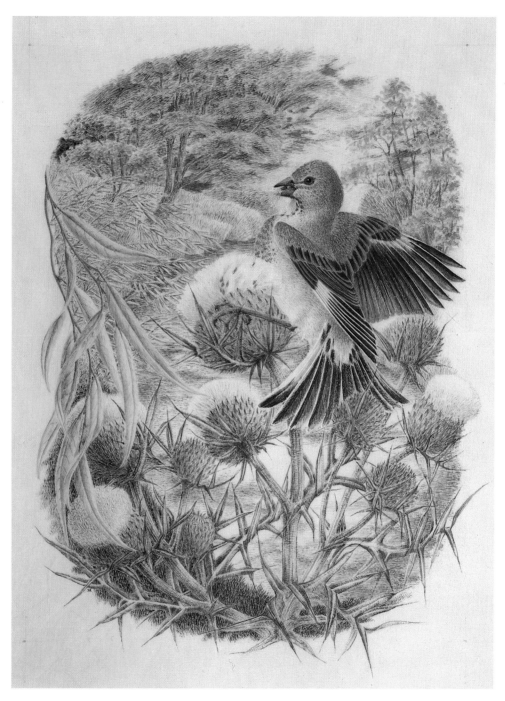

ABU'L HASAN, NADIR
AL-ASR
*Squirrels in a plane tree. Mughal
painting c. 1610. Gouache on paper.
$14\frac{3}{8} \times 8\frac{7}{8}in$ (365 × 225mm). India
Office Library, London. Primarily,
this is a very beautiful and lovingly
observed painting of a tree. The
great trunk curves across the picture, its
spreading branches and carefully
painted leaves taking up about two-
thirds of the painting's surface. The
remainder of the landscape of little
triangular hills and craggy rocks
supports the tree and gives it a setting.
The hunter climbing the tree is vital
to the composition, supporting and
adding weight to the bole of the tree.
The exquisitely drawn and painted
squirrels with their whisking tails give
movement and spontaneity to the
painting. Mughal paintings should be
studied by anyone aspiring to be a
miniature painter.*

Opposite: MARIE ANGEL
Elephant, Ocelot and Cockatoo from
Tucky the Hunter *(Macmillan/
Crown). $4\frac{1}{2} \times 6in$ (114 × 152mm).
Watercolours on cream paper. In this
drawing, a wash technique was first
used and then the texture of the
elephant's hide, and the ocelot's
markings and fur applied afterwards
with a fine brush. The curve of the
elephant's trunk is echoed in the line
of the ocelot's back and tail.*

MARIE ANGEL
Initial A with Jerboa. Decorated initial from Bird, Beast and Flower. *Watercolours on vellum. As the jerboa springs in great leaps, his tail balances his slight form and the composition of this decorated initial.*

and shuffle the feathers tidily into place, or ruffle them up and smooth them with their bills. Notice the differences in bills and feet and all the varying colours of feathers. All birds have different flying patterns, using their wings in subtly different ways; animals crouch, walk, leap and run, each in their own characteristic way. Photographs and drawings in natural history books are useful references, but for movement and spontaneity personal observations are essential.

Try to capture this individual character in the drawings. Visualise the enormous mass of an elephant in his too large hide: his ponderous and deliberate movements, his questing trunk and small wise eyes, flapping ears and bristle-tipped tail. Contrast him with the lightness and swiftness of the mouse with his delicate feet, nervous eyes, tense ears and adaptable body, which can stretch to an incredible length to squeeze through a narrow crevice or can as easily bunch into a tight ball, while the long sinuous tail balances the body as it leaps or climbs.

For the human figure, some idea of the skeleton and its proportions

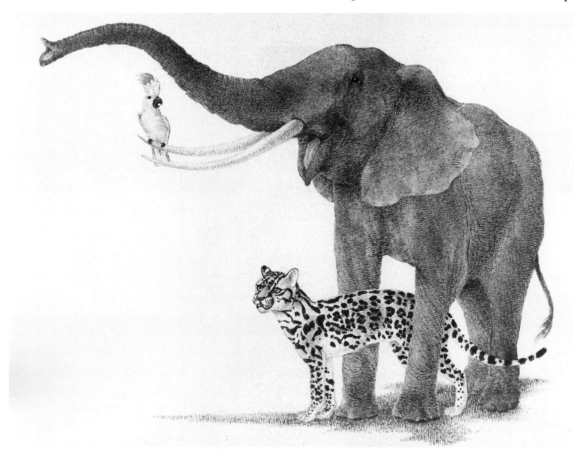

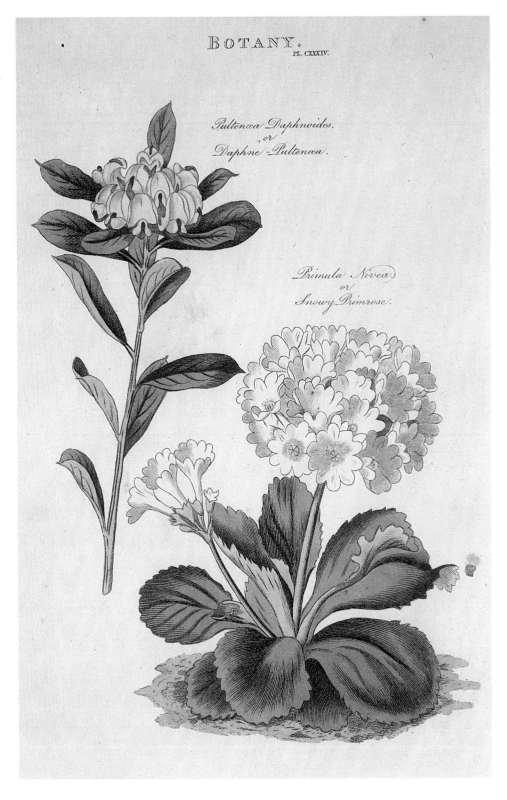

Primula and Daphne.
Handcoloured engravings from
Curtis's Botanical Magazine.
$9\frac{1}{2} \times 5\frac{3}{4}in$ *(241 × 146mm).*
Examples of the type of
botanical drawing that is both a
practical exposition of the plant
and its habit as well as being
extremely decorative.

BOTANY.

PL. CXXXIV.

Pultenæa Daphnoides.
or
Daphne-Pultenæa.

Primula Nivea.
or
Snowy Primrose.

are essential to produce a convincing drawing. Even under drapery or clothes, one should be able to feel that the bones are articulating in the right positions – that the figure is balanced with its weight properly distributed and not in an impossible pose.

For plants and flowers, understand their complicated construction. Take a flower to pieces to see how the various parts are joined together; cut across stems to find their shape in section – stems are not always round, but may be square, oval, flat, ribbed, etc. Try to see some of the work of the early botanical artists, such as Maria Merian, Georg Ehret, the Bauer brothers and Marie Anne. Most public libraries will have copies of the *Botanical Magazine* with charming engravings of plants showing the characteristic details by which they may be identified and coloured with watercolour washes.

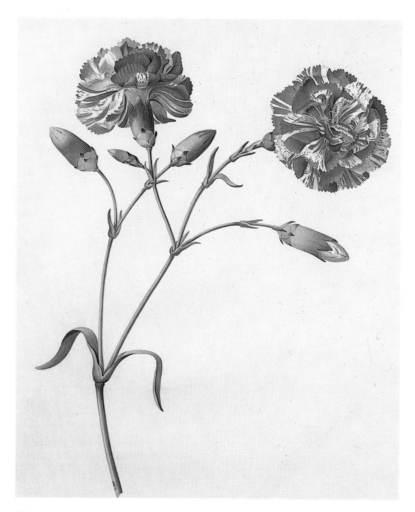

GEORG EHRET *(1708–70)*
Carnation. Watercolours on paper. $13\frac{1}{2} \times 11\frac{1}{2}in$
($343 \times 292mm$). Victoria and Albert Museum. This
superb watercolour shows clearly how a plant drawing
should be made. All aspects of the plant are displayed
in a natural arrangement of flower-heads, buds and
stems in the beautiful and sensitive painting.

57

PREPARATION

For the illumination of manuscripts, only a light, accurate outline drawing of the subject is needed, whether one intends to finish the painting in a flat decorative way or as a highly detailed miniature.

Instead of drawing directly onto the paper or vellum, place a piece of tracing paper over the space to be filled in the manuscript and draw on this using a B pencil. Do not use too much pressure when drawing or the pencil will make indentations in the vellum. With this method, you can take into account the weight and spacing of the text, the margins, and the general proportions of the page, in the same way as the early scribes did when they drew directly onto vellum, but you can make as many different drawings and alterations as you please without damaging the page.

When you are satisfied with the design, make a clear outline of the subject on a clean sheet of tracing paper. Place this in the exact position it is to hold on the page and make two or three registration marks so that it may be replaced in the correct position whenever necessary. Now turn over the tracing paper and carefully draw over the outline again, on the back, with a soft B pencil.

Replace the traced drawing on the page: take care to match the registration marks. Go round the outline of the drawing again – this time with an H pencil gently impressing it on the vellum.

It is very important that drawings and tracings should all be as precise and accurate as possible. When tracing over the same line three times, any inaccuracy will be magnified through careless tracing.

When making the drawing, the silhouette of the main subject in the composition should be concise and easily readable. This is especially important in miniature work. Within the silhouette the drawing may be highly detailed, but shape and form should be clearly defined. Paintings in books are meant to be viewed closely: the inclusion of detail holds the viewer's interest, but too much distracting detail in small paintings becomes fussy and makes them less easy to understand. In heraldry, for example, charges on the shield are adapted from the natural form of the animal, bird or plant, to a simple shape in colour contrast to its background to make it easily readable even from a distance. The simpler the main shape in the drawing, the better the final result will be. When incorporating an animal, bird or plant with a letter-form for a decorative capital, the subject should fit comfortably within the confines of the letter and not in any way obscure its legibility.

Having traced off the drawing onto the vellum or paper, either leave the outline in pencil as it is, or outline it again with thin watercolour in a light tone, using a fine pen or brush. When the watercolour is dry, any pencil marks may be erased with a soft rubber so that there

NICHOLAS HILLIARD *(1547–1619)*
Portrait of an unknown man aged 24. English 1572. Watercolours on vellum. $2\frac{3}{8} \times 1\frac{7}{8}in$ (60 × 47mm). This sensitive portrait is a good example of a simple silhouette, with the black doublet and cap highlighting the head. A diagonal rhythm runs through the painting, accentuated by the line of the green riband, with its gilt knot and edging, the small slashes in the doublet and the flash of white in the cockade.

MARIE ANGEL
Owl with T. Decorated initial from Bird, Beast and Flower.
Watercolours on vellum. $1\frac{5}{16} \times 1in$ (35 × 25mm). Although the owl obscures most of the letter, it is clearly a T because the bird does not hide the most readable part of the letter.

is no chance of the pencil rubbing off, or smudging, as one works across the painting. However, it is difficult to erase the watercolour outline, if you should want to change any details in the drawing; and if the line is too dark, it will show through the subsequent painting.

MARIE ANGEL
Swallow. Illustration from Beasts in Heraldry *(Stephen Greene Press). Watercolours on vellum. 5¼ × 3¾in (133 × 95mm). The heraldic symbol for a swallow, martin or swift is called a martlet. This depicts the bird in a formal standing position, the sickle wings folded over the forked tail, but with no legs or feet, only tufts of feathers to show where they should be.*

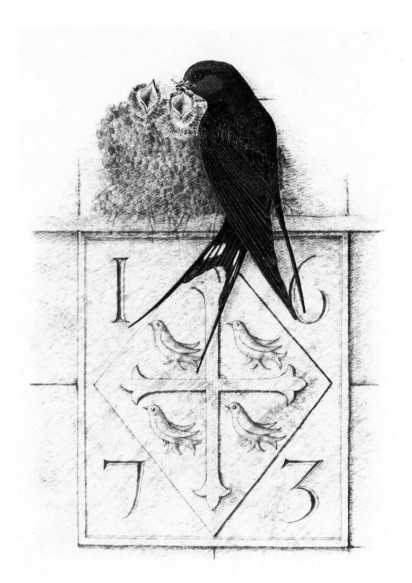

WATER COLOUR

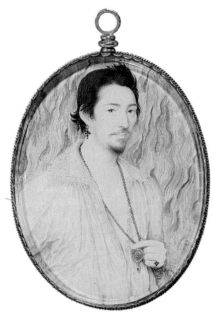

Shadowing in limning [painting] *must not be driven with the flat of the pencil* [brush] *as in oil work, distemper or washing, but with the point of the pencil by little light touches with colour very thin, and like hatches as we call it with the pen; though the shadow be never so great it must be also done by little touches, and touch not too long in one place, lest it glisten, but let it dry an hour or two and then deepen it again. Wherefore hatching with the pen, in imitation of some fine well graven portraiture of Albertus Dure* [Dürer's] *small pieces, is first to be practised and used, before one begin to limn, and not to learn to limn at all until one can imitate the print so well as one shall not know the one from the other, that he may be able to handle the pencil point in like sort. This is the true order and principal secret in limning, which that it may be the better remembered, I end with it.*

From *Art of Limning* by NICHOLAS HILLIARD

When I wanted to learn about painting miniatures, I studied the paintings of Nicholas Hilliard, whose miniatures are some of the finest ever created. I did not quite go so far as to follow Hilliard's instructions to copy engravings of Dürer, but it led me to hatching rather than a flat or stipple technique for my own miniatures.

With an ordinary watercolour, one may quickly wash in the tones of the picture so that from the first one has a general idea of how the finished work will look on completion. Making a painting built-up from small brush-strokes is quite a different proposition as each area is covered with colour so slowly that days may elapse before the entire ground has been coloured with the first layer of brush-strokes. It is a technique that requires patience, concentration and plenty of time: a painting can take weeks or months rather than days.

It is essential from the start to have in mind a good conception of the finished painting – particularly the colour scheme. Tonal quality is also important, but may be altered as one works across the painting; however, the use of strong colour in the wrong place, where it throws the whole harmony of the painting out of key, is difficult to change or obliterate.

If you do not feel able to keep in mind the picture you want to produce, make a rough colour sketch as a guide.

It is impossible to write a 'set of rules' for painting in a certain manner, but set out below are the methods and techniques that I have evolved for painting my miniatures and illustrations.

I have two palettes, one containing the warm colours, the other with the cool range. I use a lot of other palettes in which to mix my colours: to get clear, sharp colours clean water and clean palettes are vital. It

is important to judge accurately the amount of any one colour needed, as it is not easy to mix the exact colour again.

Painting animals and birds

When beginning a painting, I usually start with the main subject so that the rest of the background may be related to it. If the subject is an animal or bird, I start to build up very carefully the first layer of colour with a fine brush and using small brush-strokes.

Painting fur

When painting the fur of an animal, I follow the direction of the natural growth pattern with my brush-strokes. The way the hair grows may vary on different parts of the animal's body; sometimes the hair forms peaks and sometimes ridges where two directions meet. Each individual stroke of the brush may be thought of as a single hair – the beginning of the stroke, which is normally slightly heavier being the base of the hair and the termination of the stroke the tip.

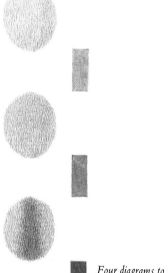

The colour of an animal's hair is very variable; often a single hair is banded with two or three colours and frequently tipped with a paler or darker tone. It is therefore difficult to mix a single colour to match an animal's coat.

I build up the coat with several layers of different colours so that the final effect approximates as closely as possible to the animal's pelt. Because of the hatching effect of the brush-strokes and the transparency of the watercolour, the first and subsequent layers of colour will still be apparent through the final coat and each layer of colour will affect the others. This effect is almost like 'pointillisme' where the painter Seurat used tiny dots of colour placed closely together to achieve the effects of light and shade which he required.

I use a lighter tone of the average colour of the animal's coat for my first layer of brush-strokes and mix up enough colour to cover the whole area to be painted. The colour should be fluid – but not so wet that the brush-strokes closely laid together are blurred or run into one another, nor so dry as to cause the brush to drag. If the colour is the right consistency, a large number of strokes may be made with one brush-load of colour and this helps towards uniformity of tone. The brush-strokes of the first layer of colour are the most important. It is very difficult to correct later brush-strokes that are not laid precisely in the right direction or strokes that were too long or too short and not in proportion to the size of the drawing, and they may still be visible in the finished painting.

It is essential that the first layer of brush-strokes should be made without interruption to achieve a smooth and regular finish. It is not easy to paint the hair-strokes evenly as any undue pressure of the brush

Four diagrams to show the various layers of colour brushwork used in painting fur.

Opposite: NICHOLAS HILLIARD
Unknown man against a background of flames. Watercolours on vellum. $2\frac{23}{32} \times 2\frac{1}{8}$ in (69 × 54mm). Victoria and Albert Museum. This beautiful miniature shows the restrained technique so typical of Hilliard. The delicate painting of the soft linen shirt with its intricate patterned lace contrasting with the strong, flickering rhythm of the flames.

NICHOLAS HILLIARD
Unknown man against a background of flames (detail). This enlargement shows more clearly the precise brushwork used by the artist, the careful modelling on the folds of the drapery and the bolder brushwork of the background flames, which are accentuated with shell gold.

MARIE ANGEL
Tiger. Illustration from Bird, Beast
and Flower. *Watercolours on
vellum.* $6\frac{1}{4} \times 4\frac{3}{4}$*in (160 × 121mm).
Stripes and other markings on an
animal should be blended into the fur;
they should follow the contours of the
body and change shape (or appear to)
on foreshortened limbs and tails.*

MARIE ANGEL
'Georgina'. Miniature painting of Siamese cat on vellum (detail). This enlargement shows the way brush-strokes are laid to simulate fur and emphasise the contours of the animal's body.

will lead to some strokes appearing darker than others. With every filling of the brush, the paint must be stirred so that the colours remain blended together and do not separate or sink to the bottom of the palette. After an interruption, I start painting again at a little distance from the previous work and paint back to that point, so that any variation in colour will not be noticeable. The brush-strokes should not be uniformly parallel, but should vary a little in direction and follow the form of the animal to give a natural look. This first layer of brush-strokes, and the care given to it, is the key to the completion of a successful painting.

The second colour is invariably a light grey used to model the form of the animal. This colour is only used when modelling is required. Miniatures do not need to be highly modelled – the silhouette of the subject is of more importance – but the form should be reasonably defined.

Apart from the first two layers of colour, there are no hard or fast rules, as obviously each animal will differ in colour and texture. Although other colours will be necessary, care has to be taken to avoid overworking or the final result will look heavy and unsuitable for a miniature. However, the third colour could well be the darker tone of the pelt. Then, finally, I add finishing touches to details such as gradations of colour on ears, tail, and feet, etc.

Spots, stripes, patches If the animal has definite markings, such as spots, stripes or patches, as in a tiger or a giraffe, I paint these markings in a lighter tone than they appear in the subject and after the first colour coat so that they lie under the grey modelling. The colour of the markings may then be intensified to harmonise with the final colour depth of the fur. If they are painted in too dark a tone at first, they cannot easily be lightened; by painting them in before the modelling, it is easier to see where the highlights and darker tones will fall for the markings to blend in with the contours of the animal.

Ticked coats and brindling can be attempted by stippling, or by manipulating the brush so that each stroke finishes with a darker spot of colour.

Painting feathers Feathers are infinitely variable in colour and if it is possible to obtain a skin or feathers for a colour match this is always worthwhile. I use the same approach as for fur to brush-work for the soft feathers of birds, such as those that cover the breast, back, and underparts.

I apply a light tone of the general colour first, but instead of keeping a smooth, regular finish as in an animal's fur, I take advantage of the brush-strokes by arranging them in the form of small feathers; by

63

ONE of the most curious is the tiny

Emu-wren whose tail is composed of

six delicate feathers considerably

longer than the body of the bird

The Emu-wren holds its tail upright

as it works through the underbrush

and lets it stream out behind when it

flies from bush tobush.

increasing the pressure of the brush on one side of these arcs, it is possible
to give a feeling of feather on feather. All brush-strokes should be
arranged to curve and follow the contours of the bird as they do in
life, and the same care should be given to the scale of the brush-strokes.

Attention should always be given to scale: the whole charm of a
miniature lies in the small perfection of its minute detail. A drawing
or painting which is small in area but has large-scale detail is not a
true miniature.

The human figure Unlike mediaeval artists, modern calligraphers do not often use the
human form with calligraphy. When figures are used, they are usually
treated in a stylised manner. Sheila Water's magnificent *Under Milkwood*
is a rare example of figures treated naturalistically.

I paint the human figure in much the same way as any other subject,
with small brush-strokes over a light wash. The face, hands, and feet

SHEILA WATERS
Portrait head from Under Milkwood *by Dylan
Thomas. Watercolours on paper. It is interesting to
compare this contemporary miniature painting of a
head with those of Hilliard.*

MARIE ANGEL
*Prayers from the Ark (detail). Watercolours on
vellum. In this painting, Noah has been drawn in with
very fine brush-strokes in layers of colours. No
washes were used. The stripes and other markings on
the tigers are blended into the fur and contours of the
animals.*

THE COLUMBAN MONASTRY OF DURROW

The Man, symbol of Matthew from The Book of Durrow. *Celtic. 680 AD. Dry ground pigments on vellum. $9\frac{5}{8} \times 5\frac{5}{8}$ in (245 × 145mm). Trinity College Library, Dublin. This impressive page, with its central, stylised figure of a man dressed in a robe intricately painted in diaper patterns, shows the richness of the colours used in early manuscripts. The border is a typical, interlacing pattern of the period, the curving, swirling lines giving movement to the whole page, with the Man as a still centre.*

are nearly always treated in a more delicate way with the features being delineated with a fine brush or pen. I use a light wash technique for clothes and drapery which can be modelled up later as desired.

In the past, I have used an underpainting of Terre Verte, but now I think this tends to look a little heavy – although it might still be suitable when a strong flat coat of colour is used for clothes or background.

Figures used in heraldry should be painted according to the blazon of the achievement (see pages 99‑100).

Plants Innumerable beautiful paintings of plants adorn the margins and initials of illuminated manuscripts (see pages 13 and 90). Flowers more than any other natural subject have been used for decoration and they may be studied both in their simplest and most complex forms, in museums and libraries everywhere. Georg Hoefnagel and Jean Bourdichon were fine exponents, scattering with great charm across their pages flower heads, insects and other small creatures, sometimes using shell gold as a shimmering background for their exquisite work.

Plants can be adapted in many ways for use in the decoration of calligraphy, ranging from the completely stylised flowers forming an almost abstract pattern to the straightforward, highly detailed, botanical drawings so loved by the old herbalists.

Flowering plants may easily be modified to fit the space one wishes to decorate. Climbing and twining plants will readily fill a border or twist through awkward interspaces such as those in K, W and M – never the easiest letters to handle. However, plants have an ordered struc‑ ture which should be carefully studied before using it in a design. Even in a formalised version of a plant the leaves and flowers should grow correctly: a pimpernel, for instance, has its leaves growing in opposite pairs and it would be wrong to place the leaves alternately, even if this aided the design; better to choose another plant that in its natural growth has alternate leaves.

When painting plants, I usually use a light wash first, keeping the wash within the pencil lines of the drawing and taking care not to obliterate any small details, such as stamens.

I examine the petals of the flowers closely before mixing the colour. I test the colour on an odd piece of the paper or vellum that I am working on and when the colour is dry, hold it against the flower to get as near a match as possible.

If more than one colour is visible on the flower petal (and often the outer edge of a petal is a deeper colour than the central portion or is a completely different colour, as in pansies), I mix all the colours

MARIE ANGEL
Four initial letters from Bird, Beast and Flower. *Watercolours on vellum. Each approximately $1\frac{1}{16} \times 1\frac{1}{16}$ in (27 × 27mm). Flowering plants – clover, violets, rose and fritilliary – arranged within various letters. These paintings show how each plant can be arranged to decorate the initial and retain its natural habit.*

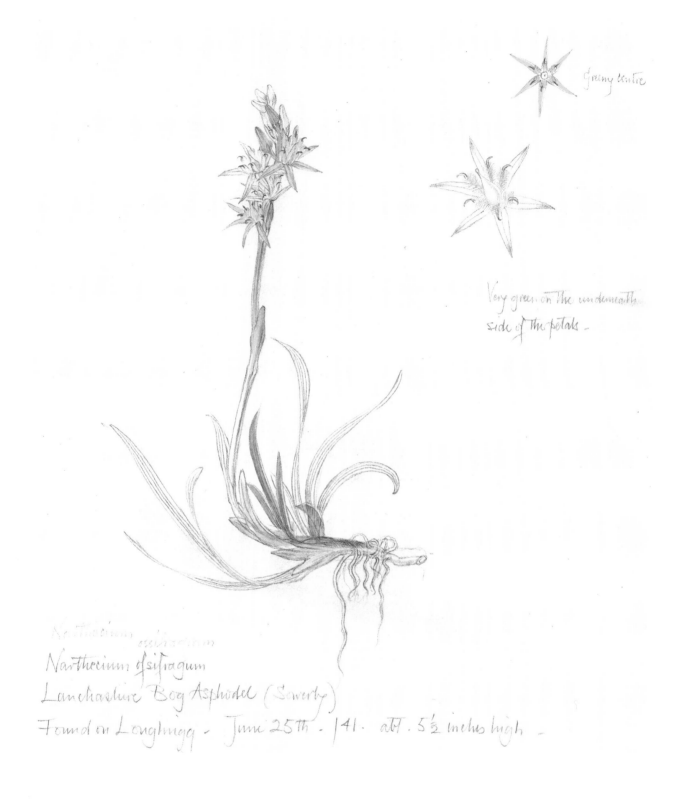

greeny centre

Very green on the underneath
side of the petals -

Narthecium ossifragum
Narthecium ofsifragum
Lancashire Bog Asphodel (Sowerby)
Found on Loughrigg - June 25th . /41 . abt . 5½ inches high .

needed before starting to paint. Separate brushes are needed for each colour: I fill them with colour before starting the wash and keep them in my left hand.

I put the first colour wash on each petal separately, starting at the outer edge. I stop where the two colours meet and, if necessary, remove excess moisture with a dry brush before flooding in the second colour so that it is diffused with the first colour. It is vital to work quickly, for if the edge of the first colour dries before the second wash is applied, a hard line will result at the meeting place of the two washes.

Petals are rarely flat: even the tiniest are often pleated, ribbed, frilled or curled, and the edges indented with notches or toothed, ragged, or smooth, and curved in various directions. These differences affect the play of light across the surface of the petals and have to be noted when applying the first wash, so that highlights can be left and shadowed areas made darker.

After the first wash, I paint in any zonal markings, such as in pinks and Pelargoniums, or streaks, stripes, etc.

I treat the rest of the plant in the same manner, taking care to match the greens as exactly as possible. Each plant has its own particular shade of green and the leaves of each plant will differ also – older leaves being perhaps darker or faded as they die off, younger leaves fresher and lighter in tone. Sometimes the stems are suffused with red or are a purplish tone, and buds, too, can be varied and quite different in colour from the leaves. The underside of leaves are often completely different in tone and colour from the upperside – cyclamen, for example, often have a delightful purple surface underneath their leaves as well as exquisite marbling above.

It is important not to have preconceived ideas about colour, thinking that all leaves are the same green and using identical mixtures for everything, or worse still, using colour directly from tube or pan without mixing at all. By holding scraps of trial mixes against a plant, one will become more and more aware of the diversities of green in every leaf as well as every plant. A more interesting and lively painting will result, if these differences are taken into account in the colour washes.

When the washes are complete, I work over them with a fine brush and using tiny strokes, especially on flower petals so that their delicate and fragile look is not lost.

The first overpainting is only slightly deeper in tone than the wash. I then gradually deepen the modelling on the petals, using as pure a colour as possible. If grey were used, the intense colour of the flower would be lost: grey is only suitable for modelling in the case of white flowers (and they often tend towards blue or green in their shadows).

DOROTHY MAHONEY
Lancashire Bog Asphodel. Life-size. Pencil and watercolours on paper. This is an excellent example of a working drawing made while the opportunity occurred and used many years later in the beautiful Lakeland Flowers Tapestry *panel (see page 113). Good working sketches should always be kept and observant notations made about colour, small details, etc.*

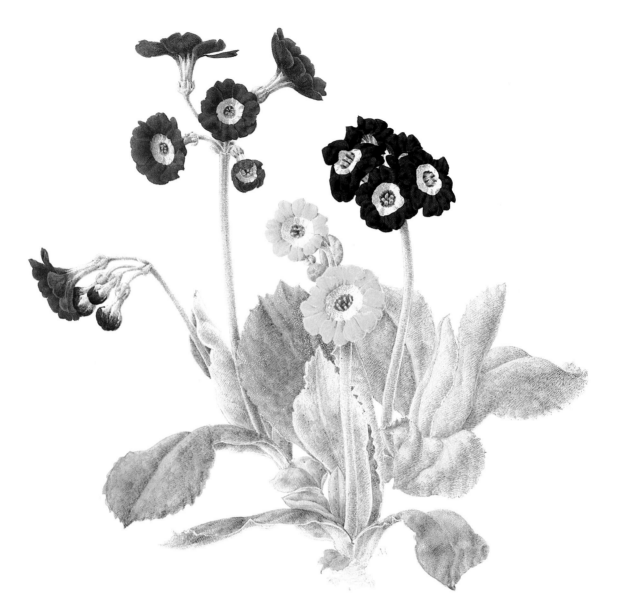

MARIE ANGEL

Auriculas. Illustration from Cottage Flowers.
Watercolours on Green's handmade paper. 6 × 6in
(152 × 152mm). Auriculas have always been
favourites with flower painters, as their rich, velvety
colours combined with the subtle, subdued greens of
their toothed leaves make them exciting plants to paint.

Petals and leaves have a thickness which is discernible at their edges and this has to be taken into account when modelling.

When using transparent watercolour, the groundwork of washes has a vital role in the painting, because with either the hatching technique or with wash, each superimposed layer of colour changes the previous one. The transparency of the watercolour should be exploited. For example, leaves that have been painted with light yellow-green wash and the modelling and texture completed with various blues and blue-

70

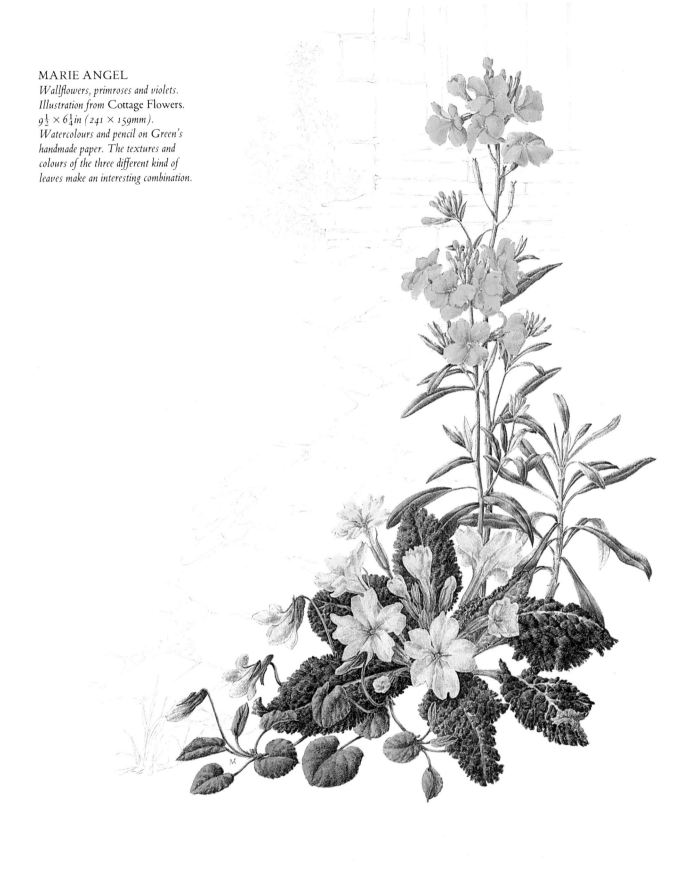

MARIE ANGEL
Wallflowers, primroses and violets.
Illustration from Cottage Flowers.
$9\frac{1}{2} \times 6\frac{1}{4}$in (241 × 159mm).
Watercolours and pencil on Green's
handmade paper. The textures and
colours of the three different kind of
leaves make an interesting combination.

PIERRE·JOSEPH REDOUTÉ
(1759–1840)
Study of Canterbury Bells 1787.
Watercolours on vellum. $15\frac{1}{2} \times 9$*in*
(394 × 229mm). Victoria and Albert
Museum. A masterly drawing capturing
the bell-shaped flowers in every stage of
their development and enhanced by the
exquisite insects resting among them.

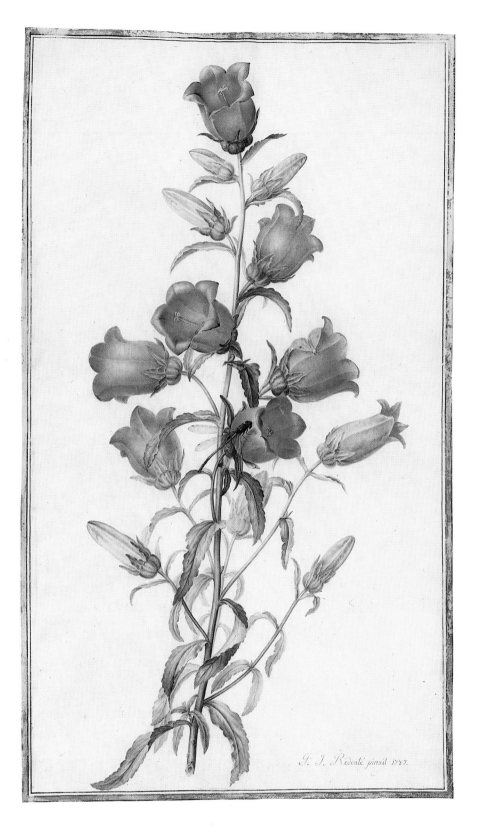

greys will be a much livelier colour than if green on green had been used. In the same way, carmine on blue can be more vibrant than a purple used alone. A pink flower will have purple or mauve in its shadows, so use blues for shading; a yellow flower tending to green will also have blue in its shadowed parts.

Stamens are best left until last and then touched in very carefully in the correct colour with the addition of Chinese white, if they are light over dark.

The centre of a flower often has very intense areas either in colour or tone and they have an important effect on the 'face' of a flower. Tubed flowers, such as foxgloves and some campanulas, have quite

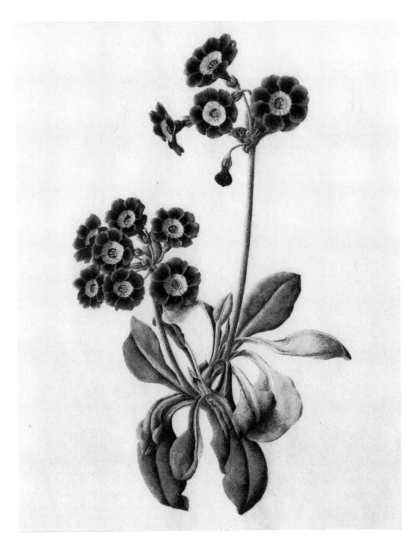

MARIE ANGEL
Auricula 'Irish blue'. Watercolours on vellum. Exhibited at Royal Academy Summer Exhibition 1958. This old-fashioned auricula was painted on vellum, which has the quality to give the richly coloured petals their full value.

73

a depth of shadow which should be carefully defined to give their hollow effect.

It is important to express the individual texture of a flower — velvety snapdragons and auriculas, the translucent quality of primroses, or the thick curling sepals of fuchsias contrasted with their skirt of thinner petals.

Foliage Leaves are modelled up in the same way as the flower, with particular attention to their characteristic texture and form. For example, auricula leaves have a toothed edge and a white meal distributed in small white dots over the leaves and stems; primula leaves are deeply channelled with veins and have a crumpled look; pinks have slim elegant leaves; *Stachys lanata* (lamb's ears) are thick and downy, covered with soft silky hairs.

Because flowers are pure colour, flower paintings can exploit the transparency of watercolour to the full. Watercolour was the medium preferred by painters such as Dürer, Redouté, Ehret and many others.

Backgrounds I use a wash technique for background details — leaves, flowers, walls, trees, or landscape.

On vellum one cannot use a genuine wash as it would cause wrinkling. Instead, I use a larger brush to put in the textures of the background subjects so that those brush-strokes are different in character from the strokes used on the main subject. I use a really thin wash and keep the brush-strokes fairly small to avoid wrinkling. This underpainting is used to simulate the texture, colour, and movement of the background. For example, the rhythm of a tree trunk, the way a wall is built of stone or brick, the texture of the leaves should dictate the way the brush-strokes are placed.

This type of underpainting is used mostly in larger miniatures — more than 1–2in (25–30mm) square. It saves a lot of laborious brush-work and gives a more uniform look to the finished painting. As this is an underpainting which will be worked over at least once in the course of painting the picture, there is no need to worry about the brush-strokes drying to an uneven tone or colour with hard edges.

These underpaintings should be kept fairly light in tone. Here visualisation of the completed painting plays an important part; the ability to select the correct tone which will need only one further layer of fine brush-strokes comes from experience. No part should be too heavy or over-painted, especially during the early stages: it is better to work up the painting gradually from light to dark, adding the most intense tones and the highlights last.

Opposite: GEORG EHRET *(1708–1770) The Black Hellebore or Christmas Rose. Watercolours and body-colour on vellum. 21 × 14⅛ (535 × 358mm). Victoria and Albert Museum. This lovely drawing is an example of how to highlight a white flower against its own leaves arranged in a very natural way.*

74

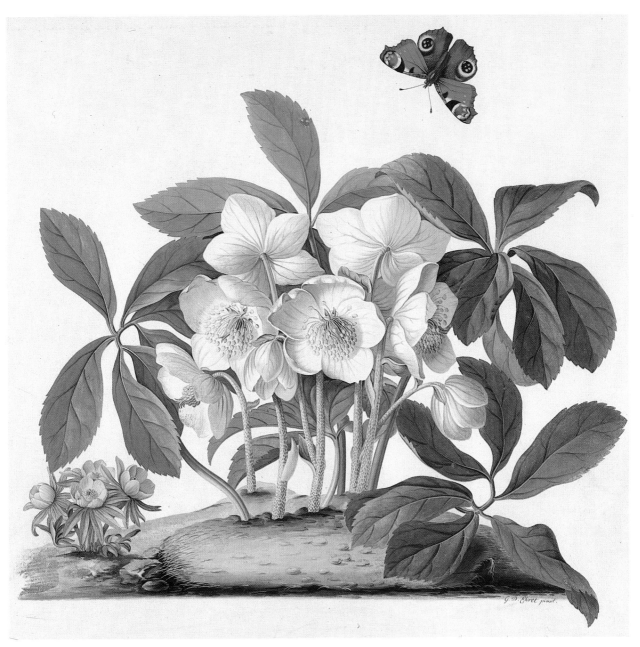

Correcting faults Having put in the main subject and background, it is time to take a good look at it before proceeding any further: to see how the main subject, painted up as far as the third or fourth layer of colour, relates to its background. The tonal qualities must be checked: for example, does part of the main subject merge with the background, because it

75

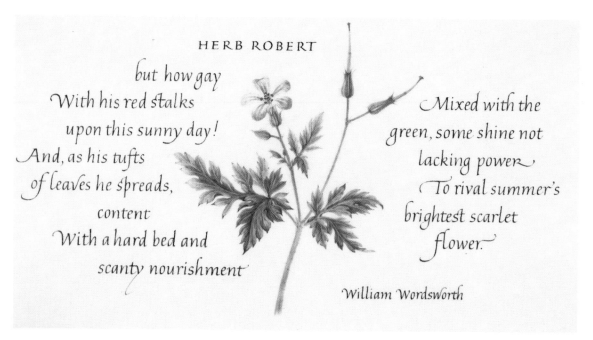

HERB ROBERT

but how gay
With his red stalks
upon this sunny day!
And, as his tufts
of leaves he spreads,
content
With a hard bed and
scanty nourishment

Mixed with the
green, some shine not
lacking power
To rival summer's
brightest scarlet
flower.

William Wordsworth

SHEILA WATERS
Herb Robert *by William Wordsworth. Watercolours on vellum. $3\frac{5}{8} \times 6\frac{1}{2}$ in (92 × 165mm). In this design, the fine, realistic drawing of the flowering plant is enhanced by the crisp precision of the calligraphy.*

is too near in tone? If this is so, which is the best solution to the problem: to darken or lighten the subject or background, or change the colour of the background? If the background is still at the wash stage, it is easier to change the background than the subject. It is possible to make a colour change without causing too heavy an appearance by using one's knowledge of colour. For example, with a brownish bird against a tree trunk, which is also brown, a soft blue wash will grey the trunk of the tree and make the bird look a brighter brown. Fine brush-strokes in blue over the wash will have the same effect.

Finishing When finishing a painting, I work outwards from the subject so that it can be related all the time to its background which should be subordinated to it. This does not mean that the subject has to be very bright or heavily painted, but it is the most important thing in your composition and should stand out reasonably well from the rest of the painting.

I work over the preliminary textured washes with a series of fine brush-strokes, using these to model over the underpaintings. A miniature painting in which everything should be finished as minutely as the main subject may need several coats of colour for each individual item. A larger illustration need not be worked over to such a high standard. In landscape care has to be taken to see that the distance is kept light in tone with less modelling than the foreground so that the effect of depth is obtained.

76

Finally the painting has to be checked over once more to make sure that edges are sharp and clean, modelling is not too emphasised, and tonal qualities are well balanced.

DOROTHY MAHONEY
Flower painting from a Christmas greeting to Lord and Lady Cholmondeley. Watercolours on vellum. 6⅜ × 4⅛in (162 × 105mm) card size. A very attractive miniature painting where the flowers and leaves are arranged in a concise pattern like a Victorian posy. The intricate filigree effect of the leaves offsets the diverse shapes of the individual flower-heads and the whole is rounded off by the scroll bearing the recipients' titles.

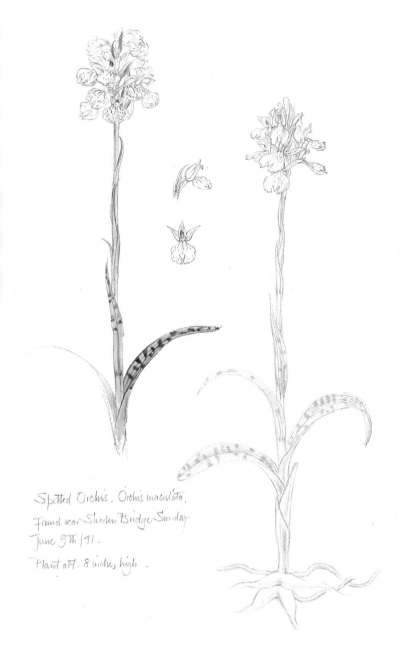

Spotted Orchis. Orchis maculata.
Found near Sheden Bridge Sunday
June 9th /91.

Plant abt. 8 inches high.

DOROTHY MAHONEY
Spotted Orchis. Life-size. Pencil and watercolours on paper. A working sketch that records fine botanical detail as well as being a beautiful drawing.

WORKING NOTES ON A PAINTING

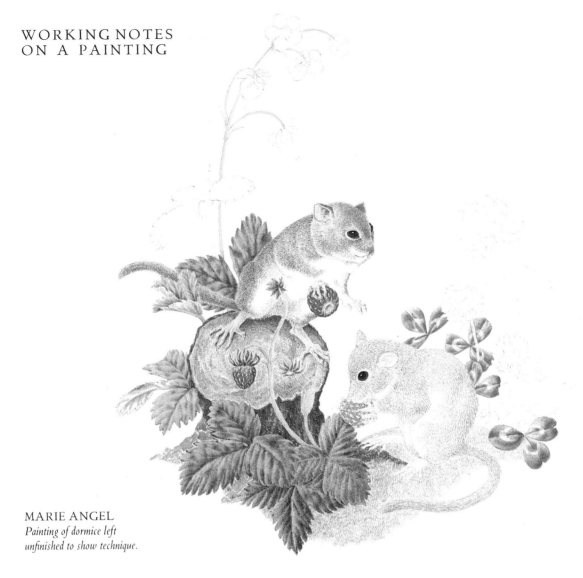

MARIE ANGEL
Painting of dormice left
unfinished to show technique.

A full page painting such as this should be kept within the text column measurements. If the text area is not already ruled on the page, lightly indicate in pencil the corners and the centre line.

The dormice were drawn roughly on tracing paper to ascertain their appropriate size in relation to the painting area (Fig. 1). As the major subject of the painting they should not be too small, but neither should they be over dominant or appear larger than life size.

The silhouette of the subject and its immediate read-ability is for me extremely important. The outline of each dormouse was drawn on to separate pieces of trac-ing paper and then moved around so that the creatures could be placed in various positions until the strongest composition was found which left the mice close enough to be in active relationship with one another (Fig. 2).

The two silhouettes were then placed on the painting area so that the upper dormouse's head was towards the centre line and above the centre point. This dor-mouse faces towards the outer margin.

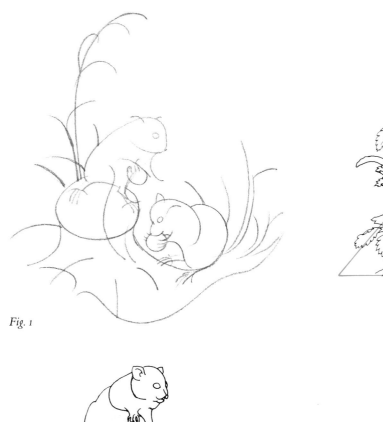

Fig. 1

Fig. 3

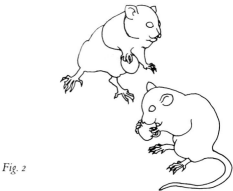

Fig. 2

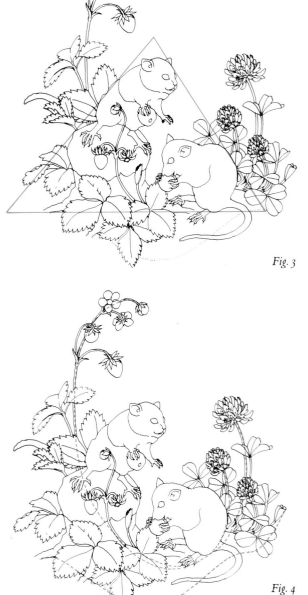

Fig. 4

Then, directly on to the page, I drew in pencil the outline of the small stump on which the upper dormouse stands. This completed a triangular composition (Fig. 3).

Next, I drew in the strawberry plant – again, directly on to the page, using natural specimens as a guide. The clover plant was drawn in a similar fashion.

The placing of each leaf is important – especially the direction of the main rib of the leaves, which by opposing the subject and the other leaf-ribs strengthens the composition.

The stems and leaves were arranged to spring from a central point and to swing upwards in rhythmic curves (Fig. 4).

When drawing the strawberries on the stems, I had to decide which were to be the reddest. Red spots dominate, so the redder strawberries had to be those held by the mice.

Finally, the area of grass was indicated with a simple line.

(Note: At this stage, some painters prefer to go over the outline of their drawing in a light colour, such as pale grey or very thinned ochre. When this has dried, any pencil marks should be removed before painting so that no smudging occurs as one's hand moves over the page in painting. I do not usually do this myself.)

With the drawing finished, it will be seen that the strong, straight lines of the triangle made up of the mice and the stump are cut by the soft curves of the plant's stems and leaves which incline towards one another and draw the eye around the composition.

After this, I studied the drawing to see if any alteration should be made before beginning to paint. I had not drawn a tail for the upper dormouse, feeling it would probably have been invisible to the observer from this position. However, it seemed an anomaly to have a mouse without a tail, so I then spent some time drawing on tails in different positions on tracing paper until I decided on one which looked natural and helped the composition.

I then started to paint the dormice, using the soft golden colour which underlies the colour of their fur and placing the brush-strokes to create a furry texture. Then I worked over the mice again, using a light-grey colour for modelling where necessary. The lower dormouse has been left at this stage so that the technique may be shown (see page 78). The upper dormouse was then completed using a deeper colour for another application of hair strokes; paws and eyes were coloured and modelled.

Washes were used on the stump and also the leaves of the plants. A broken wash of grey brush-strokes was applied first to the stump and a light-brown wash to the cut upper surface. These were then modelled in deeper browns and greys.

A light green – cobalt blue mixed with Lemon yellow and a touch of orange – was then applied to the young strawberry leaves and stems. The wash for the leaves was laid in straight strokes according to the veining of the leaves. The other leaves were painted in the same way with a darker green wash (the light green with the addition of a little Prussian blue and a touch of Indian red). Various tones of green were used over the washes in small brush-strokes to vein the leaves and model their form.

The strawberry fruits were coloured with tones of red, yellow, and yellow-green. The brightest red fruits are the ones held by the mice to draw the eye to the centre of the picture.

The grass in the foreground was added now to hold the composition together.

The painting was then left in this unfinished state and photographed for reproduction. When I started work on the painting again, washes in greens and appropriate colours were added to the outline of the clover leaves, stems and flower-heads to balance the composition.

Then the strawberry plant was also strengthened and the flower-heads and strawberries completed. The tree-stump was altered to increase the stability of the design and a distracting area of white background on the left-hand side removed. On the right-hand side a similar narrow, intrusive white area was broken-up by adding a fungus to the stump. Unpainted areas of a design are just as important to its balance as the painted areas.

The dormouse on the right, which had been left unfinished, was then painted to resemble the first dormouse in tone and colour. Any unfinished leaves were now completed and the foreground grass worked over again deepening the tone.

I continued in this way to work over each of the components of the painting until the required finish was achieved in each section.

Finally, I looked over the painting with a magnifying glass to see if any modifications were desirable and if it was necessary to make alterations in tone, colour, sharpness of detail and so on, so that finally a harmonious composition was achieved. This stage will sometimes take a whole day.

MARIE ANGEL
*Dormice with strawberry plant
and clover.* $5\frac{5}{8}$ × 5in *(143 × 127mm).
Watercolours on Green's handmade paper.*

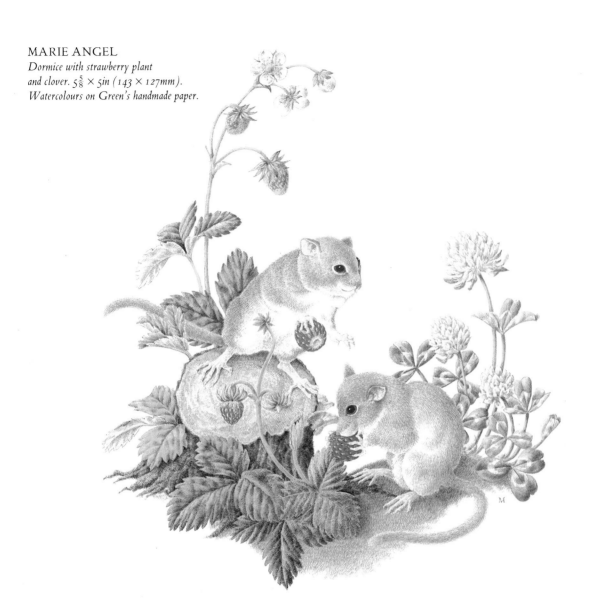

When completing a painting, do not pore over the drawing too closely all the time: sit back every now and then and look at it as a whole and note how the area you are working on relates to the rest of the painting. Changes in tone and colour can affect the whole design.

If painting for reproduction, be careful to cover any tiny patches of white paper or vellum left in painted areas: if not subdued, these can destroy tonality by showing up as dazzling flecks after processing.

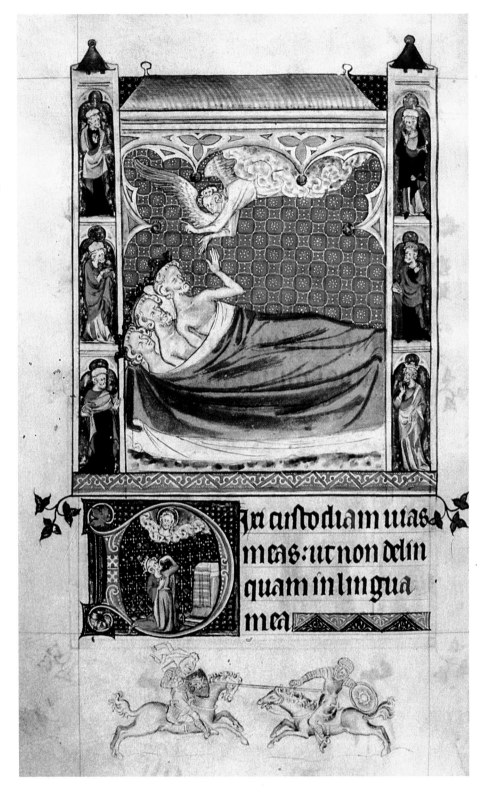

Page from Queen Mary Psalter. English: East Anglian school c. 1310–20. Dry ground pigments on vellum. $10\frac{13}{16} \times 6\frac{7}{8}$ in (275 × 175mm). The British Library. The Magi being warned by an angel not to return to Herod. In this manuscript the enormous number of tinted drawings throughout the text and lower margins have all been executed by a single artist. The figures have been drawn in a lively way with a lovely fluid line and a judicious use of colour. The small drawings of the two knights in combat are a fine example of line-and-wash drawing. This page is also a very good design – notice the balanced relationship between the initial, text and illustration.

LINE·AND·WASH DRAWINGS

Line·and·wash drawing is a natural progression from writing with a pen. Fine examples of this technique may be found in early manuscripts. It may be used successfully for many subjects and is frequently used for maps and plant drawings.

The drawing can either be freely drawn on the vellum or paper or traced on the page first.

Use a quill or a steel pen: small quills such as crow quills used to be the favourites for this type of drawing.

Do not try to have the same width of line throughout the drawing: use a square·edged pen and use its thicks and thins as you would in writing. The pen may be held at any angle – use it in any way, any direction that will add interest to the drawing. A line is a vital thing that has to suggest a three·dimensional form in a two·dimensional way. To appreciate the expressive possibilities of line, look at some of the vibrant, rhythmic drawings in illuminated manuscripts, such as the

MARIE ANGEL
Whale. Illustration from Tucky the Hunter. *Watercolours on cream Ingres paper. 4½ × 7in (114 × 178mm). In this painting washes only were used except for a few touches of texture and emphasis of line added with a fine brush.*

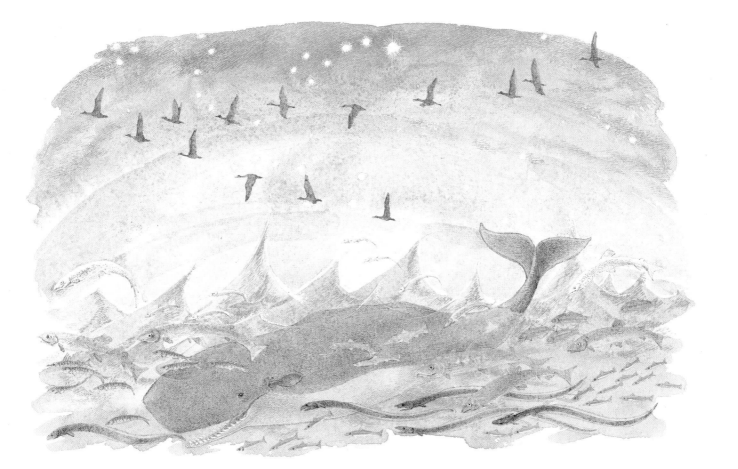

Winchester Psalter, Winchester Bible and Queen Mary Psalter. Try to see some drawings by Picasso or David Hockney who with great economy of line express such subtlety of form.

Draw in the outline of your composition with pen and ink, using the same colour ink as your text or another neutral colour which will blend with the colour washes.

Apply the washes with care: they should not be too strong in tone and should be placed to assist the modelling and rhythm of the drawing. Small details of colour may be added after the more general washes; these touches of colour may be stronger in tone.

If the ink is not waterproof, or if you are using watercolour for your line, remember to keep the washes just inside the outline or they may cause it to blur or run into the wash.

MARIE ANGEL
Capital A with Tern from Tucky the Hunter.
Watercolours on cream Ingres paper. $1\frac{3}{4} \times 2\frac{3}{4}$in
*(44 × 70mm). This A was four lines high of the
written text and decorated with a very old 'wave'
pattern. The bird has been placed so that it does not
make the letter illegible.*

GOUACHE, DRY GROUND PIGMENTS AND SHELL GOLD

Gouache colours are excellent for painting subjects such as heraldry and decorative initial letters; they are also useful for colour writing with a pen. When mixed to the right consistency, they give a good, solid colour with no risk of uneven tone.

To get the right consistency, I mix the gouache colour with just enough water so that it flows freely from the brush and is easy to manipulate. The same holds for gouache used with a pen for coloured lettering, but you will probably need a little more water to thin the colour enough for it to flow easily – too thick a mixture will clog the pen. If you want to use a dry-brush technique, you will need the gouache colour to be of a stiffer consistency than if you were brushing on a flat coat of colour. Any consistency is correct, if it procures the desired effect.

Large and small sable brushes are the best to use with gouache colours, as they need a strong brush. For miniature paintings use a very fine sable.

Colours which are rich and brilliant may be mixed together like transparent watercolours and may be mixed with them if one so desires.

Gouache colours have an advantage over watercolours in that, being opaque, one may paint over a mistake or use a lighter colour over a darker one.

These body colours give a much bolder effect than transparent water-

WENDY WESTOVER
Fraserburgh : tailpiece from RNLI Memorial Book. Watercolours and gouache on vellum. 5 × 5in (127 × 127mm) ; oval : 2in (51mm) across. Royal National Lifeboat Institution.

ND

colour. This makes them very successful when used for large decorative initials and the solidity of the colour goes well with raised or shell gold. With gouache colours effects similar to those in early manuscripts can be achieved.

Although designers' colours are manufactured to a very high standard, it is a good idea to test any colour before working with it, to make sure it will not crack or rub off at the consistency chosen for a particular piece of work.

Paint a small square on the paper or vellum; when dry, rub a finger across to make sure the colour adheres firmly to the surface. If the colour does appear to be loose a little gum water or egg should bind it firmly. If you want to rub out pencil marks after painting, take this into account: an eraser will often smudge or lift the colour even when it has passed a finger-rub test.

Gum water Gum water mixed in the proportions of approximately two-parts of gum water to one of distilled water makes a good medium. Again make a trial test: if there is not enough gum the pigment will still rub off; if there is too much the pigment is likely eventually to crack and peel off the surface. Never try to dry a work by artificial heat as this will nearly always cause cracking and peeling.

Gum is not waterproof: while it is fine for binding colours to be used for a simple flat coat of colour, any overpainting needs to be done very dexterously or the ground may shift under the second application of colour.

Egg as a medium Egg yolk is probably a better medium for painting. The egg yolk separated from the white and with the yolk-sac removed is mixed with approximately a third of its quantity of distilled water. Mix well and use. Some recommend straining the mixture through muslin, but I have never done so myself.

Egg-yolk medium gradually hardens to give a very tough and resilient surface. If the painting appears too shiny or greasy, add more water to the egg.

Egg-yolk medium may be used for very fine details in miniature painting. Some painters think that the yellow colour of the yolk spoils the colour of the pigment to some extent and prefer to use instead the white of the egg prepared as 'glair'.

Glair Separate the white from the yolk and whip it up to a very stiff froth on a plate (like making meringues!). Tilt the plate and leave it to

Page from The Oscott Psalter. *English, 1265. Dry ground pigments on vellum. 11 $\frac{13}{16}$ × 7 $\frac{1}{2}$ in (300 × 190mm). The British Library. The style of this book is a natural development from the mid-13th century illuminators, but is influenced also by contemporary French painters. In this full-page painting of a saint, asymmetrically arranged on a diapered background, the sweeping drapery and curved elegance of the figure build up a rhythm with the smaller, repeated curves of the scalloped, wave-like patterns in the border, which are in turn continued in the similar shapes on the tiled roofs. This painting uses a flat technique to achieve a three-dimensional effect.*

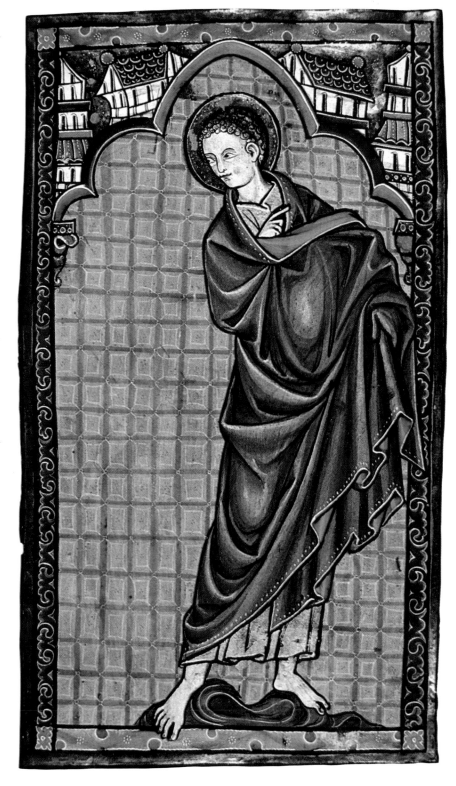

drain off overnight into a small dish. This liquid is then used as a medium.

Like the egg-yolk medium, it will keep for about a week in a refrigerator. It is possible to add preservatives to media to keep them longer, but I feel that the less outside agents are introduced the better for the ultimate well being of the painting. Glair is fine for tiny detailed work – hair strokes, dots and hatchings in white, colour, or shell gold.

I do not use my hatching technique with gouache colours, preferring to use them in flat coats. I feel this is the most suitable technique for this particular type of colour.

When using a flat technique in miniature paintings for modelling, look at some of the fine early illuminations and see how the painters managed the folds of drapery, using maybe three tones of one colour to model a curve or a fold. This type of simple painting is most effective and increases the importance of the silhouette and form of the subject which is thrown up against the single colour or diapered background. The shapes left after drawing in the subject are rather like the interspaces left in a letter and have the same importance. Background shapes and subject should be interrelated.

DRY GROUND PIGMENTS

I must admit to not caring for this type of colour – probably because it is not suited to my particular technique. However, the use of dry ground pigments is in the highest traditions of the craft and should produce the finest and most brilliant colours.

The powdered colours have to be ground down again with a medium, such as gum water, egg yolk, or glair (see pages 86, and 110–11 for methods of preparation). Unless you are making up a large quantity of colour, it is not necessary to grind it down on a glass slab with a muller. Use instead a china well-palette. Put a little powder in the well with a few drops of your chosen medium and grind them together with a glass stopper. A piece of glass rod makes a useful tool with which to mix the colours.

Again, too little gum or egg will result in the colour dusting off the surface, so make tests as usual. Too strong a medium will lead to a cracking and peeling off or contraction causing the vellum to wrinkle. A certain amount of experimentation is vital before using these colours.

I feel that powder colours, like gouache, are most suited to flat decoration where a single colour coat is sufficient: for example, for large decorative initials or lines of coloured capitals for headings, for small flowers formalised as in the borders so prevalent in the fifteenth century, for diaper patterns, etc. In other words, for the traditional methods where

SHEILA
DONALDSON-WALTERS
Card for Dorothy Mahoney.
Coloured inks and felt pens.
$5\frac{1}{2} \times 6\frac{5}{8}in$ *(140 × 168mm) open. A*
piece of ephemera where the use of
coloured inks and felt pens is perfectly
valid and has resulted in an amusing
and colourful greeting.

their brilliant and jewel-like colours are shown to advantage and the difficulty of handling the colours is minimised. Dry ground pigments are not suitable for the hatched technique that I normally use, since they feel too thick and heavy. It is also difficult to mix very subtle colours, as the method of mixing is so laborious.

Each different type of colour has its own inherent qualities which should be displayed in the best possible way, but creative craftsmen's individual innovations will lead to personal methods so that each period of history produces its own style.

ACRYLICS I have experimented with acrylics, but I do not consider them to be at all suitable for use on vellum and would not use them on paper, either. They might have some use for posters and other outdoor work

89

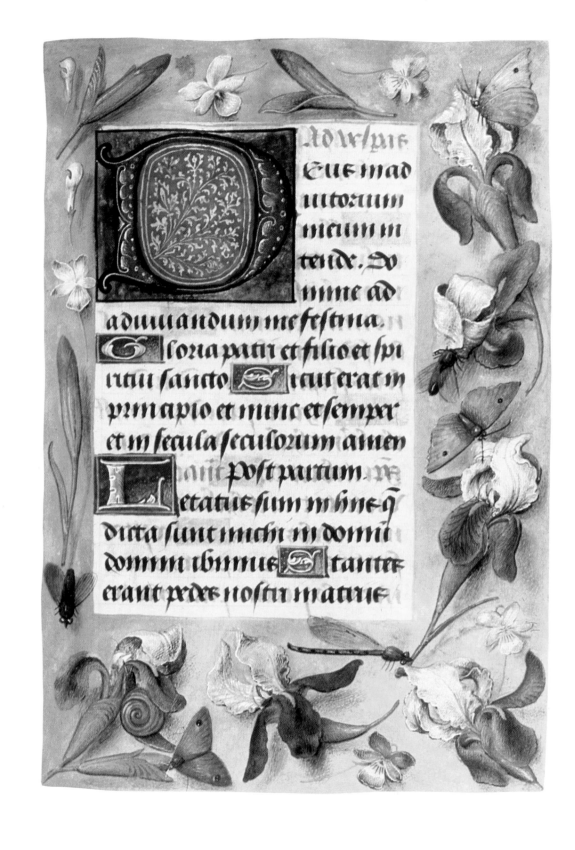

Adiutorium

Deus in adiutorium meum intende. Domine ad adiuuandum me festina. Gloria patri et filio et spiritui sancto. Sicut erat in principio et nunc et semper et in secula seculorum amen. Post partum. Letatus sum in hiis q dicta sunt michi in domu domini ibimus. Stantes erant pedes nostri in atriis

as they are waterproof, but not for manuscript books and broadsheets.

SHELL GOLD

Shell gold is very effective used over a good intense colour in gouache. The background colour should be deep enough in tone to throw up the gold in contrast. The lovely deep blue used in mediaeval manuscripts or a blazing Vermilion look very rich if worked over in shell gold.

Flat areas of shell gold for backgrounds may be laid either before or after any decoration, but hair lines and small decorative patterns laid on coloured backgrounds must be laid last of all to retain their crisp freshness.

Making shell gold

This is the method advised by Whileys, the main suppliers of shell gold in the United Kingdom:

To use real gold powder, dissolve the smaller piece of one of the isinglass capsules in a china egg-cup full of boiling water. When cold pour away two-thirds of the water. If the remainder is free and not too 'stodgy', then drop the gold powder into it and it is ready to use. If, however, the liquid is too thick, fill the egg-cup again with boiling water and, when cold, pour two-thirds away.

If the gold powder is then not rich enough on your work, steam some of it away. The gold powder will not evaporate out of it and you will have a richer mixture. If the colour is too rich, add a little more water.

Irene Base's method is given on page 110.

The Hasting Hours. Flanders, c. 1480. Written and illuminated by an unknown artist of the Ghent-Bruges school. Dry ground pigments on vellum. 6½ × 4¾in (165 × 120mm). The British Library. This superb border of irises, and blue and white violets on a background of shell gold is an outstanding example of an illusionist border, one of the hallmarks of the Ghent-Bruges school. Note how it is filled and turned by linking the line of a petal or leaf and the angle at which the flowers are displayed so that each one leads into another, creating movement and carrying the eye around the page. The primary initial has some fine gilded decoration lightly, but exquisitely, painted. The perfect proportion of the large initial in relation to the text rectangle, the weight of the lines of writing, the area of the decorative margins, the low-key tones of the smaller initials and the delightful colour scheme make this page a model design.

DECORATED INITIAL LETTERS

The art of illumination started with the decoration of the initial letter which over a period of time became elaborated into borders, historiated initials and miniature paintings.

Today, decorated initials are mostly used in traditional works, such as charters, letters patent, loyal addresses and memorial books, where they are often combined with heraldic devices. Otherwise, a simple coloured letter is considered sufficient.

In my own work, I often use decorated capitals for personal mono‑grams and cyphers using animals, birds or flowers combined with Roman letters. I have also used capitals decorated in the same way in printed work with type or written text.

DESIGNING INITIALS

When decorating initials, the underlying structure of the letters should remain reasonably legible. Choose the type of letter form, Roman or Uncial, Lombardic perhaps, which seems most appropriate to the text writing. Try to keep initials to the correct proportions, remembering to measure their height according to the line spacing of the text.

Look closely at the interspaces left when your drawing is placed within the counterspaces: these spaces become very important to balance the drawing and the initials; they may also contribute greatly to the rhythm of the design. If you are able to choose the subject for the cypher or monogram, creatures which move easily like cats, mice, squirrels, chipmunks, tigers, crocodiles, monkeys, etc., especially if they are able to climb, may be deftly twisted and turned through the letters. Birds, too, having a soft and varied flight, may be arranged to fly through counterspaces or uprights and to perch on the crossbars or stems of letters. Close‑growing plants with well‑spaced, good‑sized flowers and interesting leaf‑shapes are the best to incorporate with capitals.

The letters should be readable and the interlacing or use of a common stem should not diminish this. For instance, junction points of stems should not be obscured if this makes the letter illegible. Initials of sur‑names should be given precedence over first names: for example, with R.M., it would be easiest to link the R to the common stem on the right‑hand side of the M, but this could well give the impression that

Page from The Bedford Hours and Psalter. *c. 1420–22. Dry ground pigments on vellum. 16 × 11in (405 × 280mm). The British Library. This very fine manuscript in the style known as 'International Gothic' was made in the workshop of Herman Schleere in London. The large historiated initial depicts the marriage of David and is painted in rich, glowing colours within the framework of the initial, which is itself counterchanged in blue and red. Note the fine proportions of the overall design and the excellent placing of the great initial letter in relation to the weight of the borders and text. The artist uses heraldry in a richly decorative way, with the shield hanging like a pendant at the foot of the page.*

Opposite:
JOAN PILSBURY
Initial letter from a Life Peerage Letters Patent. Artists' watercolours with Chinese white, dry ground pigments mixed with gum arabic. 4 × 4in (102 × 102mm).

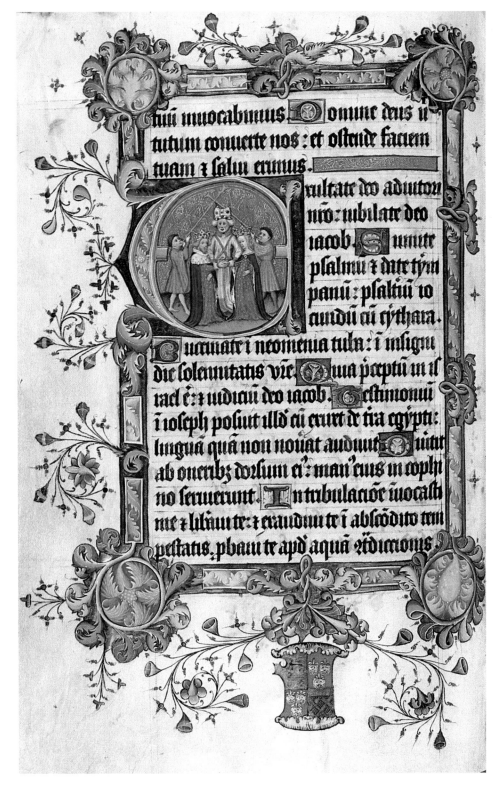

MARIE ANGEL
Initials CH with Cheetah. Watercolours on vellum. $3\frac{1}{4} \times 3\frac{1}{2}$ in (83 × 89mm). Private commission. The initials have been flat-painted in blue-grey. It was difficult to fit the cheetah with these initials without making them illegible. The arrogant pose reflects the cheetah's character and the strong diagonal of the body opposes the upright of the H to increase this attitude. The tail curling round the C carries the eye again to the diagonal running up to the proud head.

MARIE ANGEL
Initial A with Hare. Illustration from Tucky the Hunter. *Watercolours on paper. $1\frac{3}{4} \times 2\frac{1}{8}$ in (44 × 54mm). The initial has a small repeating pattern with the hare leaping through the upper part of the letter.*

R is the surname. It would be better to reverse the R onto the left-hand stem of the M, thus putting it in the right sequence and by reversing the letter making it less dominant.

Colour is extremely useful in cyphers to show the different initials used. It does not have to be sharp, contrasting colour: a quite subtle difference is enough for the eye to read the interlacing.

For very large letters, it is probably better to draw, or even rule in, the uprights or trace the whole letter in the space to be filled. Do not keep too rigidly to ruled lines, as this will give a mechanical appearance not suitable to a written manuscript. Alternatively, write the letter with a quill as a versal and decorate it with brush-work afterwards.

When letters are made in the versal manner, a decided space is left in the centre of the uprights and the bows of curved letters. These spaces lend themselves to patterning and may be filled with contrast colour, shell gold, or more complex patterns such as counterchanged and interchanged diaper patterns, foliage and strap work.

For flat-painted initials in a single colour which are to receive simple decorations such as contrast outlining, shell gold, coloured background, diaper or more intricate patterning, but all in flat colour coats, I make

the letters using a brush in the same way as I would a quill to make versals.

In early manuscripts, coloured dots are used constantly to outline initial letters and inked or coloured outlines help to lift the letter to a dominant position on the page.

Initials can also be decorated by developing the framework of the letter itself into decorative leaves, scrolls, animal and bird forms; or the initials may be made up entirely of different objects, such as the zoomorphic capitals used in some early manuscripts with four fishes making an E or a human figure as the upright of I.

My preference is for plain Roman initials in a single colour which contrasts well with an animal, bird or foliage occupying the counter-space. When making a drawing for a cypher or monogram, my method is to keep the legibility of the letters by joining them as simply as possible, and when arranging the subject within the letter forms displaying it in a natural way with a readable silhouette. Interlacing of animals, birds and plants with the letters need only be loosely applied; enough alternation between the two forms to create a link is all that is necessary.

MARIE ANGEL
Initial F with Macaw from
Tucky the Hunter.
Watercolours on paper.
$2\frac{7}{8} \times 1\frac{1}{2}in$ *(73 × 38mm).*
This capital is patterned with a small, repeating design, the colours harmonising with the gaudy feathers of the Macaw.

MARIE ANGEL
Aqua et Aves. *Manuscript book. Watercolours on vellum.* $10 \times 7\frac{1}{4}in$ *(254 × 184mm). This type of lettering is not much used, but occasionally it may suit the design of the manuscript better than conventional lettering.*

Some groups of initials may seem impossible to interlace or join in any way that makes a good design and yet leaves enough room for the subject matter. When this difficulty arises, it is safest to put the capitals close together on the same line, as a pyramid, or asymmetrically, according to the initials chosen. This will often look far better than forced interlacing – particularly if good spaces are required for the drawing.

One or more rectangular capitals with several uprights to be combined with a number of straight-legged animals or tall linear plants can prove very awkward. Since forests of legs and stems do not look good, some of the legs can be concealed by having an animal in the foreground lying down and the other standing behind it with its hind-legs partially hidden. With thin, linear plants, it is sometimes possible to take some perspective view of the plant – drawing it from above, which may make a more solid and interesting pattern, and shortening stems can make quite a difference. Avoid making the flowers too small and the whole thing too 'bitty' in an effort to keep the stems and flowers in their correct proportions. It is better to put in slightly larger flowers closer together than in life so that you have a good decorative pattern.

Creatures with rigid body structures which cannot be turned or twisted – such as tortoises, butterflies and moths, molluscs, etc. – are another problem. Drawing them from unusual aspects can help – especially with solid creatures such as the tortoise which can only move its head and legs in a minimal way.

MARIE ANGEL
W with Fledglings and Chestnut branch. Decorated initial from Bird, Beast and Flower. *Watercolours on vellum. 1½ × 2in (38 × 51mm). Small, complicated pieces of pattern and colour are woven through the W without hiding the readable shape of the letter.*

MARIE ANGEL
M with Cat. Decorated initial from Bird, Beast and Flower. *Watercolours on vellum. 1½ × 1⅜in (38 × 35mm). Arranging birds and animals with M, W and K is usually difficult because of the structure of the letters. However, cats are lithe, adaptable creatures and this one sits fairly comfortably in the letter waiting for her saucer of milk.*

The movement of insects is also restricted by their structure; for example, butterflies when resting tend to show the underside of their wings. It is more difficult to arrange them so that both the upper and lower surfaces of the wings show and, whichever way they are drawn, it is not easy to interlace them with initials, because of the rigidity of their wings and flight. One way of overcoming these difficulties is to have two butterflies, one with the wings spread and one with them shut, resting among the capitals; then the beautiful and intricate markings on both sides of the wings may be simply displayed.

HERALDRY

Aesthetically, calligraphy and heraldry are a perfect combination – the bright, pure colour and use of gilding are ideally suited to any calligraphic hand.

Nearly all calligraphers at some time or another will become involved with heraldry. County councils, churches, universities, colleges and schools, banks and other commercial institutions are all likely to commission a piece of calligraphy and all will probably use arms or badges and other insignia based on heraldry as a means of identity. Heraldry, therefore, has to be designed for all sorts of different purposes: from the magnificent achievement carved in stone over a college gateway to a letter heading or the arms painted on the side of a county council's van or dustcart.

Presentation and award certificates, letter-headings, freedom scrolls, memorial books, are the most usual commissions. Nearly all will require a good, well-balanced design including the coat-of-arms of the particular body concerned incorporated with the text.

Before designing any heraldry, it is necessary to have a good working

Below left: DOROTHY MAHONEY
Coat of Arms from Roll of Honour since the Second World War of the Royal Engineers. Watercolours and raised and burnished gold on vellum. 18 × 12in (457 × 305mm) approx. A regimental memorial book is the kind of commission that will entail the use of heraldry. Here the coat of arms has been admirably designed and painted in traditional colours with raised and burnished gold.

Below right: DOROTHY MAHONEY
Badge of the Royal Engineers from Roll of Honour since the Second World War of Royal Engineers. Watercolours, raised and burnished gold on vellum. 18 × 12in (457 × 305mm). This military badge is an adaptation of some items from the coat of arms.

ROLL OF HONOUR

SINCE THE SECOND

WORLD WAR

WENDY WESTOVER *(painting)*
JOAN PILSBURY *(calligraphy)*
Fraserburgh page from the RNLI Memorial Book.
Watercolours and gouache on vellum. This complete
page shows how heraldry and a miniature landscape
can be cleverly linked together by decorative borders.

FRASERBURGH

28·IV·1919 **Andrew Noble** *Service to the*
'Drifter 'Eminent'

Andrew Farquhar

9·11·1953 **Andrew Ritchie** *Service to*
Fishing Boats

George Duthie

Charles Tait

James Noble

John Buchan

John Crawford

21·I·1970 **John Stephen** *Service to m.f.v.*
'Opal'

Frederick Kirkness

knowledge of the science of heraldry. There are many reliable books on the subject and I have included some of the most well-known in the reading list on page 123. All of these should be available in a public library.

ACHIEVEMENT An ACHIEVEMENT is the correct name for all the various objects which make up what people call a 'coat-of-arms'. (The original 'coat' was a surcoat of linen worn over armour, to protect the wearer from the heat of the sun; the bearer's arms, the same as carried on his shield, were embroidered on the front and back.) A full achievement incorpor-

99

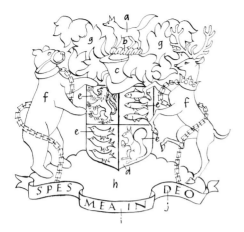

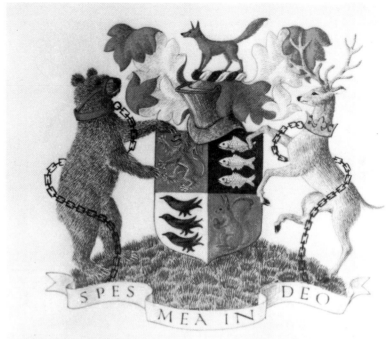

An achievement:

a crest f supporters
b wreath g mantling
c helm h compartment
d shield i scroll
e charges j motto

ates the shield, which with its charges is the most important part of the coat of arms, the helm, the torse or wreath, the mantling, the crest, the supporters, and the motto. All these may stand in a compartment – usually a slight mound painted to look like turf. Sometimes badges are also added.

BLAZON

The BLAZON, or written description of the achievement, enables the heraldic artist to draw the coat of arms correctly, but leaves him free to make from it his own original design.

EMBLAZONING

EMBLAZONING is the drawing and painting of the coat of arms.

Drawing an achievement

When drawing an achievement, bear in mind that the shield, helm, crest, wreath and mantling at one time existed in three dimensional form. It is helpful to study armour, either in a museum or in other collections, to see the relative sizes of helms and shields, and how they were made. It is a good idea to make sketches of helms in particular, as they are difficult to draw with authenticity unless one has some knowledge of their workmanship. The shape of shields and helms varied according to the period in which they were made and used. Perhaps the ideal period was the Middle Ages when heraldry was very much

part of everyday life and when arms and armour were well understood.

So adaptable is heraldry that an achievement may be designed to fill virtually any shape or space required. Shields may be tilted, supporters compressed to fill an upright rectangular design or broadened for a wider space. Mantling, too, may be used decoratively to fill and balance an awkward shape. However, unless you are well versed in heraldry, simplicity should be your aim. In the Middle Ages when heraldry flourished and the armour, crests, surcoats and standards were common, everyday objects, the drawing of arms and armour had a simple directness rarely seen today. One may learn a great deal about design for heraldry by looking at decorated manuscripts of the time.

SHIELDS

For the SHIELD, the plain 'heater' type, which is about one third longer than its width, may be used in most instances. However, for quartered arms, a squarer type of shield makes it easier to display the charges. When only a shield is to be depicted the elegant, narrow shields of the eleventh and twelfth centuries are delightful for slim rampant lions or other narrow charges.

Decide on the width of the top of the shield. Draw the lines AC and BD a third of the length of AB and at right-angles to it. With compass points the width of AB, place point on C and draw line from D to E.
Reverse placing of compass and draw line from C to E. This completes the outline of the shield.

A Two different forms of shield which might be useful for some blazons.
B A charge such as a lion should fit comfortably within the shield. Note the relative evenness of the areas of the shield not occupied by the charge.

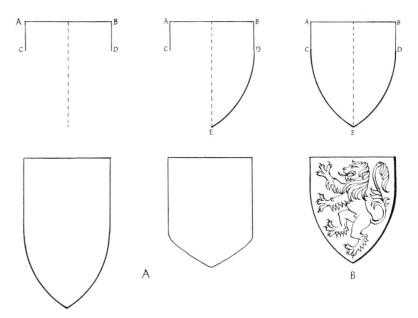

The proportion of the shield to the helm is important. The width of the top of the shield should compare approximately to the width of the bearer's shoulders and the helm should be rather larger than the head would be.

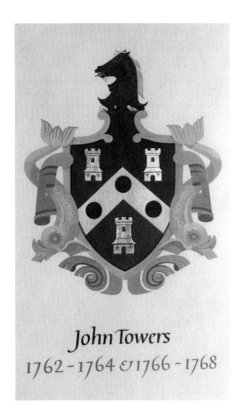

John Towers
1762 – 1764 & 1766 – 1768

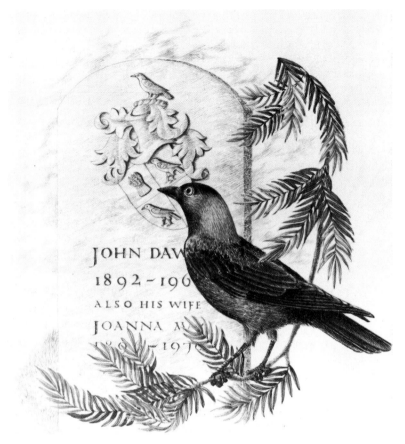

JOHN DAW
1892 – 196
ALSO HIS WIFE
JOANNA
– 19

CHARGES The CHARGES on the shield should be carefully placed by eye to give an even balance in proportion and scale between charges and field. As a guide, a single charge, such as a lion rampant, should fit easily and comfortably within the dimensions of the shield. The lion should not look cramped with its head knocking against the top of the shield nor should it be so small that it appears weak and powerless.

When drawing charges on a field, even though the pencil drawing may appear well-balanced, a light background – especially of burnished gold – will cause a dark charge painted on it to look smaller. The converse – that a light or burnished charge will seem larger against a dark background – is also true. Allowances should be made for this optical illusion.

HELMS HELMS vary according to rank and are placed above the shield in certain positions also according to rank.

102

Far left: WENDY WESTOVER
*Coat of Arms from the record of the Prime Warden
of the Fishmongers' Company. Watercolours,
gouache and powder colours with shell and gold leaf
on vellum. 12½ × 9½in (318 × 214mm). A coat of
arms of rich gold on sable, decorated in subtle, low-key
colours.*

Left: MARIE ANGEL
Jackdaw. Illustration from Beasts in Heraldry.
*Watercolours on vellum. 5 × 5in (127 × 127mm).
This shows the bird in the natural form contrasting
with the stylised heraldic symbol cut in stone.*

MANTLING

WREATH

CREST

The *Royal Helm*, used by the Sovereign and Royal Princes, is of gold and is always placed on the shield facing towards the front. The opening is guarded by gold bars.

Peers have a silver helm with bars of gold; the helm is shown in profile facing to the dexter.

Baronets and *Knights* have a steel helm with an open vizor facing the front; the padding with which the helm is lined may be of blue or red.

Esquires and *Gentlemen* also have a steel helm with closed vizor, usually shown in profile and facing to the dexter.

The MANTLING was originally a thick cloth used to cover the helm to protect the wearer from the heat of the sun. After hard wear in travel and during battle, the mantling became torn and frayed and this was reflected in the ragged, cut, and more ornate mantling now used more commonly than the original short cloth.

Mantling is shown turning or twisting to show on the upper side the main colour of the shield and on the underside the main metal.

Although some fussy examples of mantling may be seen, fussiness is not desirable. Ideally, mantling should be kept simple with a vigorous and flowing turning of the cloth to set off the achievement harmoniously and fill decoratively the space provided.

The WREATH should fit firmly round the helm, holding the mantling in place and providing a good base for the crest.

The wreath has come to be represented by a twisted rope of cloth of which six twists are shown; they are usually painted alternately with the main metal and the main colour of the shield.

Sometimes coronets are used instead of wreaths. Peers have their coronets incorporated in the achievement and placed on top of the shield and below the helm.

The first CRESTS were modelled in leather, wood, or metal and worn on the helm, being so made that they were not too cumbersome to wear in battle. Later, much more elaborate and fantastic structures were made and used for tournaments and pageants. The best examples to study are early models, effigies, tombs and brasses, etc., in churches and museums.

When drawing a crest, it should be in suitable proportion to the helm so that it looks neither too small nor too large and unwieldy. It should be of reasonable size and should appear to be securely attached to the helm, as obviously no one would want to ride into battle with

a large object wobbling around on his head. The crest faced forward and turned with the wearer's head: as the fixed rule of position of the helm remains, it is often necessary to have a sideways view of the crest even when the helm faces front.

MOTTOS

MOTTOS when used are usually placed on a scroll below the shield. In Scotland they may be above the crest.

The scroll on which the motto is inscribed is not obligatory but is common. The folds of the scroll may be designed to accept easily the words of the individual motto. The lettering may be in any hand and be rendered either in capitals or minuscules. If the achievement is part of a book or is being used in conjunction with a text, it is a good idea to use the same hand for text and motto.

SUPPORTERS

SUPPORTERS – whether human figures, mythical or naturalistic beasts and birds – should appear to be of a suitable size and strength and to be capable of supporting the shield. They should be drawn with vigour and spirit and stand high enough for their heads to be above the top of the shield. Although stylised, supporters also have form and this should be conveyed in your painting.

PAINTING HERALDRY

Gouache or body colours are best for painting heraldry. They give a good, flat coat of colour and their brilliance and opacity are ideally suited to the subject. As some of the colours have a very good covering capacity, they may be painted over other colours.

Colours

Colours used in heraldry today tend to be pure, vivid colours with the addition of black and white. It is customary to use a red near to Vermilion, a blue which neither tends to green nor red, a purple with equal proportions of red and blue, and a green which does not lean to blue or yellow. If a yellow is used for gold instead of gilding, it may be either a brilliant yellow or ochre or a mixture of ochre with a little black which looks similar in tone to gold.

Shell gold is very useful in heraldry and may be burnished if desired. I prefer the flat look which seems in some ways more in keeping with the flat surface of the shield. Raised and burnished gold, however, looks quite magnificent if well done and would seem essential for a really important piece of work. If one cannot gild well, a painted 'gold' colour looks better than poor gilding; where minute charges have to be painted on a shield, it is easier with a 'gold' colour than it would be using either shell gold or raised gilding.

Argent or silver is normally left white. It is possible to use silver

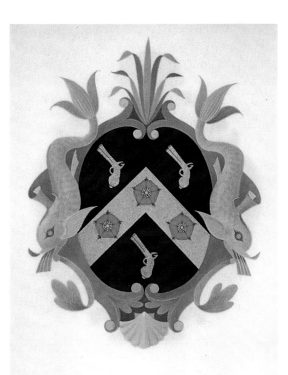

Sir Richard Hopkins
1730–1732

JOAN PILSBURY
Coat of Arms from the record of arms of the Prime Warden of the Fishmongers' Company. Watercolours, gouache and powder colours with shell gold and gold-leaf on vellum. 12½ × 9½in (318 × 241mm). This cartouche in various soft greys and ochres provides a well-designed and finely painted background to the arms emblazoned with sable, gules and or.

DOROTHY MAHONEY
One of two panels of the names of Provost and Fellows buried in the chapel of King's College, Cambridge. Watercolours and gold on vellum. 30 × 14in (762 × 356mm). Here the coat of arms is well placed at the head of the long column of beautifully written names. The simple shield shape is admirably suited to the austere hand and layout of the panel. Heraldry often forms part of a commission from colleges and schools.

NOMINA PRAEPOSITORUM COLLEGII REGALIS

WILLIAM MILLINGTON		1441
JOHN CHEDWORTH		1447
ROBERT WODELARKE		1452
WALTER FIELD		1479
JOHN DOCCET		1499
JOHN ARGENTINE	✠	1501
RICHARD HATTON		1508
ROBERT HACUMBLEN	✠	1509
EDWARD FOX		1528
GEORGE DAY		1538
SIR JOHN CHEKE		1549
RICHARD ATKINSON		1553
ROBERT BRASSIE	✠	1556
PHILIP BAKER		1558
ROGER GOADE	✠	1570
FOGGE NEWTON		1610
WILLIAM SMITH		1612
SAMUEL COLLINS		1615
BENJAMIN WHICHCOTE		1645
JAMES FLEETWOOD		1660
SIR THOMAS PAGE	✠	1676
JOHN COPLESTONE	✠	1681
CHARLES RODERICK	✠	1689
JOHN ADAMS		1712
ANDREW SNAPE		1720
WILLIAM GEORGE	✠	1743
JOHN SUMNER	✠	1756
WILLIAM COOKE		1772
HUMPHRY SUMNER	✠	1797
GEORGE THACKERAY	✠	1814
RICHARD OKES	✠	1850
AUGUSTUS AUSTEN LEIGH		1889
MONTAGUE RHODES JAMES		1905
SIR WALTER DURNFORD		1918
ALAN ENGLAND BROOKE		1926
SIR JOHN TRESSIDDER SHEPPARD		1933
STEPHEN RANULPH KINGDON GLANVILLE		1954

BURIED IN THE CHAPEL ✠

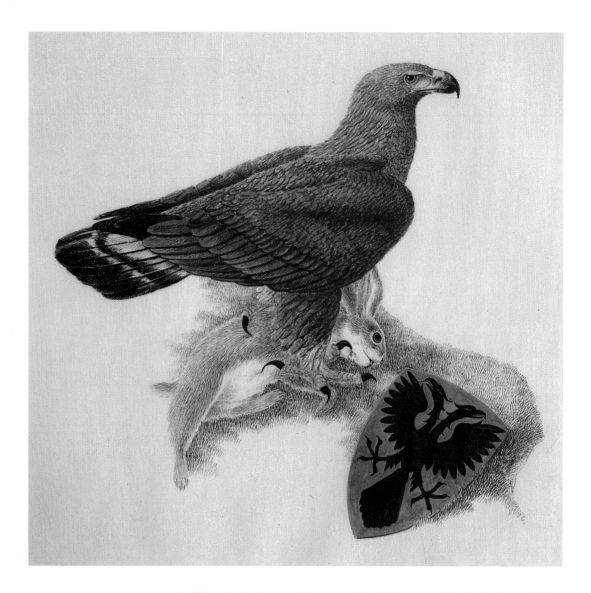

leaf, but it darkens with age and will become black in time. Other metals might be used, but are difficult to handle; white, either Chinese white or the surface of the paper or vellum, would seem the most practical answer.

Although pure colours are customary today, there is no reason why more subtle colours should not be used heraldically as they often were in previous centuries. As long as the blazon is followed accurately, any green may be used – from blue to yellow-green; or red from blue-red to orange-red; or dark to light blue. The danger with using a varied

colour range is that the colours may become confused through lack of contrast. A blue-red may look very like purple or a very dark blue might be seen as black. Clear, vivid colours, well-defined against the metals, are easily recognised.

Shields Charges or fields in either raised or shell gold must be laid first. When the field is in colour, the silhouette of the charges may be sharpened by judicious use of the brush. In a similar way, when the field is gilded, the charges may be painted lightly over the gold surface so that the edges are sharply defined. It is not easy to paint over burnished gold, as colour tends to run off the shining surface, but by using an opaque colour, fairly dry in consistency, it will adhere and help to seal the edges of the gold. It is simpler if unburnished shell gold has been used – but again the colour should not be too wet.

If a gold colour is used, charge or field may be painted in any order.

When the metal is silver, which is normally left white, the order in which the charges or field are painted may be left to individual choice.

Left: MARIE ANGEL
Eagle. Illustration from Beasts in Heraldry.
Watercolours on vellum. 8 × 8in (203 × 203mm).
This drawing combines the eagle as it looks in life
with a shield charged with the highly stylised symbol
of the two-headed eagle, often used in heraldry. For
work which is to be reproduced by a printing process,
it is better to use a simulated gold colour as shell gold
and raised, burnished gold are difficult to reproduce.

MARIE ANGEL
Horse. Illustration from Beasts in Heraldry.
Watercolours on vellum. 5½ × 5¼in
(140 × 133mm). Here the white horse stands easily
beneath the inn sign depicting the heraldic symbol of
a rampant horse in its unnatural pose.

MASTER OF THE
DUKE OF BEDFORD
The Bedford Hours. *French
15th century. Ground pigments on
vellum.* $10\frac{1}{4} \times 7\frac{1}{16}$ *in
(260 × 180mm). The British
Library. This richly decorated and
illuminated manuscript was
written and painted in Paris for
John, Duke of Bedford and shows
scenes from the Gospel of St
Matthew. The delicate filigree
border sprinkled with gilded leaves
and with flowers and fruit painted
in intense, glowing colours is a
perfect setting for the brilliant
miniatures. The coats of arms of
the Duke and Duchess of Bedford
are most imaginatively arranged
and displayed on the page and are
a fine example of heraldry used in
a richly decorative way.*

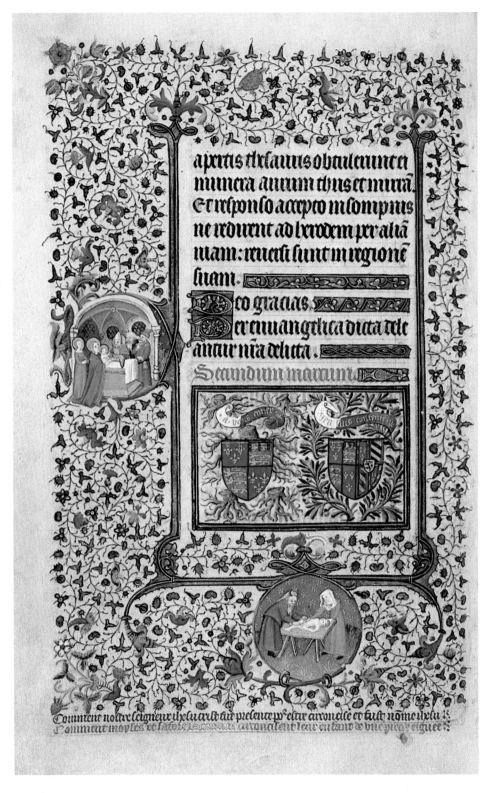

After painting, a line is usually drawn round the charges in black. This is not obligatory and, if the charges and field are sufficiently defined by colour and silhouette, unnecessary especially in miniatures.

A line round the shield itself always looks well. This line may be slightly heavier round the sinister side of the shield to give an appearance of solidity and depth.

Helm The helm should be painted to resemble metal and modelled enough to give a three-dimensional appearance. It is customary to presume that the light is falling from the left.

The wreath or torse should be painted to show the twists of cloth and the mantling shaded slightly to show the form and depth of the material.

The crest and supporters should also be lightly modelled to give their three-dimensional value, but modelling should not be overdone in heraldry. Just enough should be used to give value to the forms; details such as eyes, manes, feathers, etc., should be as simple as possible.

In a decorative miniature, however, far more detail may be used: while clarity is still as important, a wealth of detail is permissible in a painting which is intended to be looked at closely.

The compartment may be a plain green or painted with tufts or blades of grass to resemble turf. Plants may be introduced in an informal or formal manner. The plants are often related to the arms, such as the daffodil or leek, the shamrock, rose, and thistle, often used on the mount in the Royal coat of arms. The designs of plants used in mediaeval tapestries make good examples to follow for this purpose.

When drawing for heraldry, simplicity of silhouette is important, especially when charges are small in size: if the silhouette is clear, they will still be readable however tiny.

Drawings of beasts and birds should be vigorous with plenty of rhythm and movement. The animals displayed should look fierce, war-like creatures – cosy, cat-like lions have no place in heraldry. Again, early examples make a worthwhile study.

JOAN PILSBURY
Initial letter from a Life Peerage Letters Patent. Artists' watercolours with Chinese white, dry ground pigments mixed with gum arabic. 4 × 4in (102 × 102mm). A large E in raised gold with the finely painted decoration striking a happy balance between the traditional, heraldic colours used for the crown and shield and the more subtle ones of the surrounding rose and thistle.

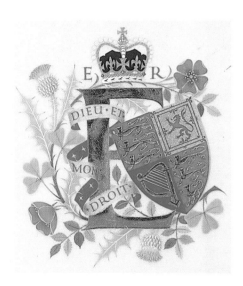

NOTES ON TECHNIQUE

BY

CONTEMPORARY

SCRIBES

IRENE BASE

In a letter to Dorothy Mahoney, Irene Base gave these notes on how she prepared gold powder for use as shell gold:

I don't use gum arabic as a medium for gold powder, though I know Cennini recommends it; it never seems to make the gold bright enough.

The best thing I think is gelatine – pure leaf gelatine, and for $\frac{1}{4}$dwt of gold powder a piece about this size [$\frac{1}{2} \times \frac{3}{8}$in (13 × 10mm)] would probably be enough. I dissolve the gelatine in a teaspoonful of hot water. Shake the gold powder into it and stir until it is cold. Then I think it is a good thing to test a little on a scrap of vellum to see if it is 'tight', but I never like to use it at once because the gold powder seems to be floating in such an enormous quantity of water that the result looks thin; so I always wait until it has dried, and then moisten a little with a brush dipped in distilled water. An agate seems to be the best for burnishing.

IDA HENSTOCK

In various letters written to me in the last months of her life, Ida Henstock told me the following about her way of using pigments. Powder colours were always used mixed with egg medium, yolk plus distilled water for some colours, a complicated mixture with beaten-up egg white for others, including all the 'fili-gree'. For some of the solid part of the work — inside initials and borders a half yolk, half distilled water proportion was used. Her recipe for the glair she personally used is also given in The Calligrapher's Handbook:

Use one white of egg beaten stiffly and left overnight for the liquid to run off. To this liquid add half-teaspoon of French white wine vin-egar and half-teaspoon of gum arabic. Allow to dissolve and strain. Then add quarter-teaspoon sal ammoniac dissolved in the minimum amount of warm water and strain. For use this mixture should be diluted with distilled water.

110

THOMAS INGMIRE
The Bestiary

The Bestiary

Since the book was fairly short (six text pages), the steps in which the pages were completed were opposite to those involved in traditional book-making.

Fairly complete drafts were done for each page so that on the final pages the text blocks were defined, the animals drawn, and the versal letters located, all very lightly with pencil.

The animals were drawn with a quill pen using Chinese stick ink. The large versal letters were done next, using the cake Vermilion mixed with water (distilled water is used in all steps) and a few drops of egg yolk.

Then the text was completed, again using a goose quill and ground Chinese ink, followed by the writing of the small capital letters in the margins which listed various beasts' names. These small letters were made with Winsor and Newton's gouache in a tube, mixed with water and a little egg yolk.

The next to last step was the gilding. Gesso was used – the 8–3–1–1 of plaster, lead, sugar, glue – and bole. The application of gold leaf was not difficult for the letters, but care had to be taken not to let the gold stick to the ink around those spots of gesso within the drawing of the beasts (e.g. the hooves of the beast shown in the photograph).

The very last step was the application of colour to the beasts. The colour was mixed – Winsor and Newton watercolour and Chinese ink very diluted and applied as a wash with a brush.

The book's pages were of Whatman cream mould-made paper.

I mix my gesso with glair – fifty per cent egg white, fifty per cent water – and allow to dry overnight.

Kalevala

The *Kalevala* was done on classic vellum – the final size approximately 25 × 26in (635 × 660mm).

A very detailed draft was completed before undertaking the final piece.

The vellum was sanded with 3M wet or dry paper (grades 320, 360, and 400), polished just a little with silk, and dusted with gum sandarac (only in the areas of writing).

Since the vellum was so large, it was not stretched. This helped to define the chronology of the steps involved in its execution. All the ruled work was undertaken first, since the vellum at the outset was in its flattest state.

The knots and borders were ruled using shell gold and a ruling pen. The blue lines within the knots were put in next, also with a ruling pen.

The black text writing was completed following this, again because

Opposite: IDA HENSTOCK MVO
Initial capital from a Shakespearian sonnet. Powder colours, raised and burnished gold on vellum. Commissioned by Richard Harrison.

COME AND SING WITH ME THE STORIES

Kalevala

the vellum was still flat, and unaffected by the moisture from the ruled lines.

The large blue areas within the knots were painted, using a mixture of Winsor and Newton's gouache and ground powdered pigments (ground with gum arabic and water).

The small writing within the blue background of the knots was done with a brush using shell gold. Additional gum arabic was added to the shell gold to help it from spreading on the blue ground.

The work on the rest of the piece is fairly self explanatory, perhaps with the exception of the centre panel.

After unsuccessful attempts to dye the panel blue and do the gilding over this, the panel was scraped clean with a knife – and the letters written with gesso (mixed as for *The Bestiary*). The leaf was applied using a haematite burnisher and 24ct gold from Whileys. After cleaning up the gold, the blue background was painted carefully around the letters.

The final piece was stretched around plywood, which had been first painted with a coat of PVA glue mixed with chalk (whiting). The board was then covered with 4ply 100 rag acid-free museum board.

DOROTHY MAHONEY
Lakeland Flower Tapestry

Sketches for Lakeland Flower Tapestry.

I was invited in 1971 by the craft members of the Society of Scribes and Illuminators to produce a broadside to be presented to Miss Heather Child, who was at that time Chairman of the SSI. I was entirely free as to what I wrote and/or illuminated; no size was suggested, no particular material was given, but since it was for a formal manuscript, I chose vellum.

Heather Child is a botanical artist as well as a calligrapher, so I decided to do a broadside using plants. During the 1939–45 war, I taught calligraphy at the Royal College of Art which had been evacuated to Ambleside; there I became acquainted with the wonderful wild flora of the Lake District and was able to sketch the plants in their natural habitat, on fells, bogs, beside streams and tarns. That is how the *Lakeland Flower Tapestry* evolved. The quotation from Wordsworth married happily with the Lakeland flowers. I regarded the flowers as the warp threads of my tapestry and the poem as my weft to weave through the flower warp.

The size of my panel was $11\frac{1}{4} \times 14$in (286×356mm) with a 2in (51mm) margin all round; after the vellum was stretched, the overall size increased by 2in (51mm) all round.

I admire the botanical illustrations of James Sowerby in Sir James Edward Smith's *English Botany or Coloured Figures of British Plants* (1832) and I used a similar approach in my treatment of Lakeland flora. My sketches were in pencil with watercolour used only to indicate colour in parts of the plants. I made a tracing of each plant and experimented with various arrangements, keeping the tall vertical plants on the outer sides, like a selvage, and the shorter ones I placed in between.

On a second piece of tracing paper $9\frac{1}{2} \times 14$in (241×356mm), I

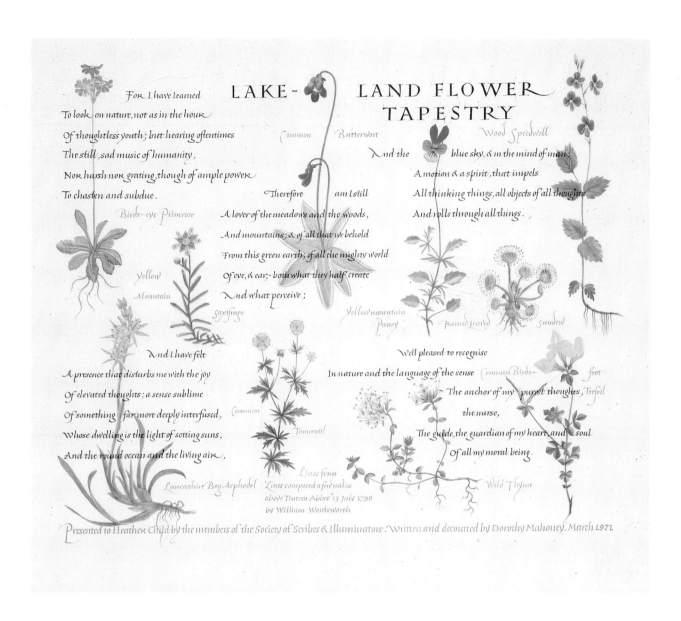

Within the illustration, the following calligraphic text appears:

LAKE-LAND FLOWER TAPESTRY

For I have learned
To look on nature, not as in the hour
Of thoughtless youth; but hearing oftentimes
The still, sad music of humanity,
Nor harsh nor grating, though of ample power
To chasten and subdue.

Common Butterwort

Wood Speedwell

And the ... blue sky, & in the mind of man:
A motion & a spirit, that impels
All thinking things, all objects of all thoughts
And rolls through all things.

Birds-eye Primrose

Therefore ... am I still
A lover of the meadows and the woods,
And mountains; & of all that we behold
From this green earth; of all the mighty world
Of eye, & ear,- both what they half create
And what perceive;

Yellow Mountain Saxifrage

Yellow mountain Pansy

Round leaved Sundew

And I have felt
A presence that disturbs me with the joy
Of elevated thoughts; a sense sublime
Of something far more deeply interfused,
Whose dwelling is the light of setting suns,
And the round ocean and the living air,

Well pleased to recognise
In nature and the language of the sense
The anchor of my purest thoughts,
the nurse,
The guide, the guardian of my heart, and soul
Of all my moral being.

Common Tormentil

Common Birds-foot Trefoil

Lancashire Bog-Asphodel

Wild Thyme

Lines from Lines composed a few miles above Tintern Abbey 13 July 1798 by William Wordsworth

Presented to Heather Child by the members of the Society of Scribes & Illuminators. Written and decorated by Dorothy Mahoney. March 1971

Lakeland Flower Tapestry. Presented to Heather Child and on display in the Crafts Study Centre Collection, Holburne Museum, Bath.

ruled in all my 'weft' lines; the distance between these writing lines was $\frac{1}{2}$in (13mm), the height of the writing $\frac{1}{10}$in (2mm). I wrote out the poem freely interlacing the lines of poetry to make a quiet secondary pattern. To give unity of weight the delicate plants demanded a light-weight writing, for which the Italic hand was most suitable. A Gothic black letter would have been incongruous with the light tone and delicacy of the flowers.

When I was satisfied with the planning and arrangement of the panel

TOWN HOUSE WROTHAM
KENT
1620 — 1975

Home of Nancy Stanfield since November 1975

THE TOWN FARM HOUSE, BARN AND YARD

The Orchard	Great Ranger	Chalk Pit
Barn Field	Little Ranger	Churchlane Field
Little Staples	Bitmans Field	Maiden Field
Great Staples	Coneybury Field	Pasture Field
White Hill	Elm Field	Plain Mead
Round Kings Hill	Churchfield	Little Field
Long Kings Hill	The Warren	Plain Field
Common Field	The Butts	

THE PRESENT STATE OF WROTHAM [1759]
The Town of Wrotham is situated close at the bottom of the chalk
hill; in the midst of it stands the Market Place & the Public Well, both
which ought to be repaired by the Lord of the Manor. It has a Fair
annually on the 4th May for horses, cattle etc. & had formerly a
market on a Tuesday, which has been disused for many years.
Extract from The History and Topographical Survey of the County of Kent
by Edward Hasted of Canterbury MDCCLXXXII Volume II

NORTH
The Orchard
Butts Hill
The Parsonage
Stone Garden
Lady Pembrokes Walk
Kitchen Garden
Courtlane
Robt. Wybarn fecit anno
Backside
TOWN HOUSE
Bull Lane
Kemsing Lane
Backside
Mr. Brian free.
Mr. Hutchinson
Mary West
Orchard
A detail of Parte of the
Mannor of Wrotham
in Kent
Surveyed in May 1620
by John Hine
Oak Cottage My Home
Mr. Veanee
Freely drawn from the original
by Dorothy Mahoney May 1976

I prepared my vellum, using pumice powder rubbed over the whole surface, shaking off the residue and then very lightly dusting with fine powdered sandarac. I lightly drew the flowers and the weft lines with a 2H pencil; then I painted the flowers with a fairly fine sable brush, starting with a light wash and gradually strengthening the tone where necessary. The writing was done after the painting was complete. I dusted over a little extra sandarac where there was writing over painting. The poem was written with Chinese stick ink, the names of the flowers in pale blue opaque watercolour, the last line in a pinky mauve echoing the colour of the bird's eye primrose and the common butterwort.

I made a special guard which covered the whole panel while painting and writing so that grease from the hands could not spoil the surface of the vellum.

A narrow fillet of wood or mounting board placed between the glass and the vellum to prevent condensation or mould is a must when a manuscript is painted or gilded.

Town House, Wrotham This decorative map was designed for the home of a friend.

Before starting on the design, I needed to know where the map would hang. Town House has a long narrow hall, which is itself framed as one enters by an unusual curved ceiling, which has at the far end a handsome woven curtain from Nigeria. In this hall the position of various doors and the staircase allowed only narrow wall-spaces, so that the space chosen for the map was much deeper than wide. The panel is therefore $17\frac{1}{2} \times 6\frac{1}{4}$in (444 × 159mm). The width of my map fixed, I had to plan the arrangement of the three items I wished to incorporate into my panel and varied slightly the depth of each portion:

1 A sketch of Town House in Kemsing Lane with cows crossing the road from the field to the byre for milking. (This was a special request as Town House used to be a farmhouse.)

2 A list of names of fields belonging to Town House c.1756, many of which still retain the same names.

3 A freely copied map of Wrotham village in the Manor of Wrotham in 1620. A number of these houses, including my own cottage, still exist.

My method of working was the same as for my *Lakeland Flowers* panel: I outlined with a fine pen everything in the first and third panels, adding where necessary thin watercolour washes; I used pure Vermilion for certain parts of the map and a green wash round the outline of some of the fields and meadows.

After completion, I sent the vellum to be stretched. Then I did the gilding and the map was framed.

JOAN PILSBURY

Joan Pilsbury sent me these notes on the materials and methods she uses:

*Bushy
Park*

John Leman

1604-1606

All Winsor and Newton Artists' watercolours – mostly pan – used with more, or less, Chinese white. In *Bushy Park* paintings, very little white used at all.

In the Fishmongers' and Letters Patent, quite a lot of white used to make colours as flat and solid as possible.

The 'illuminating' colours – red, blue – are powder colour mixed with gum arabic.

The brushes used are Winsor and Newton sable, Series 7.

All the work illustrated is on vellum.

JOHN PRESTIANNI

I have no special method that anyone who has ever tried watercolour will not be able to determine from the piece, but this is the story. That bit of Tennyson brought to my mind's eye an image of trees and water, and I had been thinking of ways to combine painting with lettering in a way that would display my own individual style of working. (I was a student of painting before I ever heard of calligraphy.)

So, I did several small preliminaries to get a working image. Then I did a detailed layout of the lettering, which by the way evolved into a separate piece of its own, reproduced in *Modern Scribes and Lettering Artists*.

I adjusted the painting to accommodate the layout.

I took some lovely old Hayle Mill hot-pressed rag paper and pasted it to millboard in a nipping press. In this way I had a flat surface that would not buckle when the rather puddle-like washes had been applied. (One could also use illustration or ragboard, but the old paper is much better, having been specially made and sized for watercolour.)

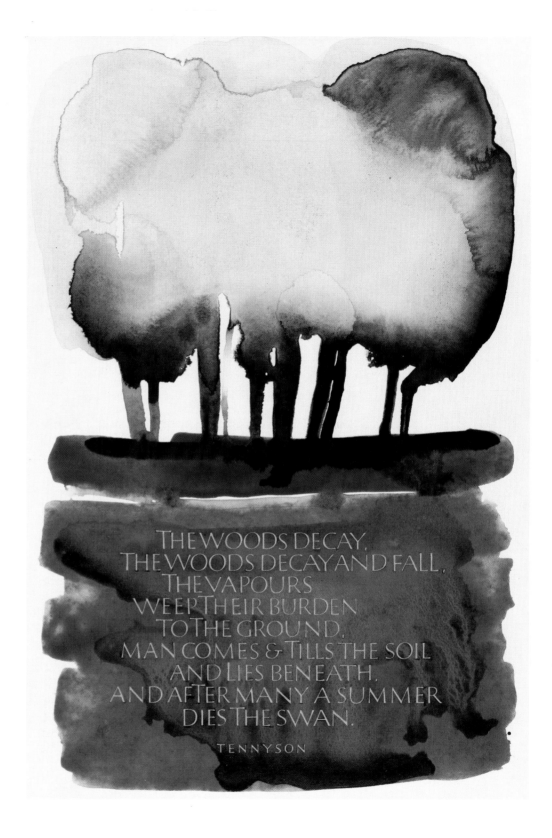

THE WOODS DECAY,
THE WOODS DECAY AND FALL,
THE VAPOURS
WEEP THEIR BURDEN
TO THE GROUND,
MAN COMES & TILLS THE SOIL
AND LIES BENEATH,
AND AFTER MANY A SUMMER
DIES THE SWAN.

TENNYSON

I laid on the washes with a large flat sable brush and several smaller round brushes (also sable).

I did three paintings and selected the best one, because watercolour can be unpredictable in the way it dries when used 'wet-in-wet' (as opposed to 'dry brush').

For this type of thing one must be loose and flexible enough to accept (even welcome) the accidental quality as a desirable thing. As with calligraphy itself, it gives life to the work.

As far as 'flooding one colour into another', that can be dangerous and easily overdone, spoiling the work. It's important to restrain oneself to begin with and, even more important, to know when to stop. But that is a matter of experience I feel, as with anything else.

The question of one's intention must be reconciled with the accidentalness I referred to above. I think that the idea, the image, is the most important thing, but that process is somewhat indescribable. In fact I am not even sure where my ideas come from!

SHEILA WATERS *Sheila Waters sent me the following notes on her new* Roundel of the Seasons:

The Roundel The colours were mostly Winsor and Newton's Artists' watercolours and gouache, sometimes mixed together, plus Pelikan Graphic White, mixed and alone. There is no acrylic, no egg, etc.

Light refraction was kept to a minimum, so the finish is quite matt, even 'chalky'.

This work, although on vellum, was designed specifically for the production of colour prints by means of Cibachrome II.

By means of proofing, I modulated colours and tones according to the way they would come out in the print medium and I truly like the prints better than the original – the colours are more subtle. The vellum for this work was stretched over an aluminium core. The colour scheme is highly intricate, being an orchestration of the full spectrum modulating through the months of the year in careful tonal balance.

Sheila Waters likens her original work for this Roundel to a lithographic stone or plates from which original lithographic prints are made. After each proofing of the original the colours were adjusted and balanced to reflect the vibrancy and depth of brilliance obtainable from the Cibachrome II process. It is illustrated overleaf.

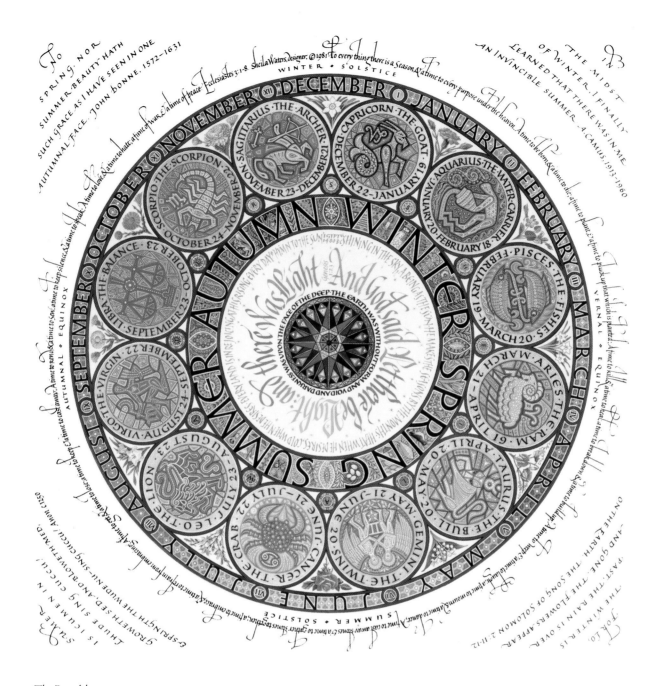

The Roundel.

WENDY WESTOVER
RNLI Memorial Book

In painting a miniature, the oval was drawn in pencil in its position on the vellum, then painted in as a light-grey solid. The view was then drawn on to the grey solid using a fine brush and a darker tone of the same grey. Finally, colour was introduced to this monochrome foundation.

Broome Phillips Witts
1840 - 1842

For the border round the view, the design was first worked out very carefully on paper. The skeleton of the design was then traced on to the vellum in pencil and the border completed directly with the brush, first in pale grey and then in final colours.

The paint was gouache, used with as little water as possible and a deliberately restricted number of colours (the basic five being Zinc white, Yellow Ochre, light red, Cobalt blue, and Lamp black).

Heraldry paintings

These designs were traced on to the vellum in pencil and painted mainly with gouache colours.

The field of the shield was in each case painted with powder colour to get an evenly opaque area more easily, using gum arabic as the medium. With both kinds of paint, as little water as possible was used.

The gold was of two kinds, gold powder with gum arabic as the medium and/or gold leaf on parchment size.

121

JOHN WOODCOCK

John Woodcock sent me some notes to say that he uses various materials to gain his effects:

Square-cut pastels plus ink applied with a flat brush.

Acrylic colours used over resist.

Coloured inks applied with a flat square-cut brush over resist with letters in black ink applied over these foundations whilst still damp.

FURTHER READING

The Art of Calligraphy by Marie Angel (Robert Hale (U.K.); Scribners (U.S.A.)

An Artist's Notebook (Techniques and Materials) by Bernard Chaet (Holt, Rinehart & Winston)

The Craft of Calligraphy by Dorothy Mahoney (Pelham Books (U.K.); Pentalic (U.S.A.)

The Materials of the Artist by Max Doerner (Rupert Hart-Davis)

Notes on the Technique of Painting by Hilaire Hiler (Faber & Faber)

Writing, Illuminating and Lettering by Edward Johnston (Pitman)

HERALDRY

Boutell's Heraldry revised by J. P. Brooke-Little, MVO, MA, FSA, FHS, Richmond Herald of Arms (Frederick Warne) – very comprehensive

An Heraldic Alphabet by J. P. Brooke-Little (Macdonald) – similar to a glossary

Heraldic Design (A Handbook for Students) by Heather Child (Bell) – very practical

The Observer's Book of Heraldry by Charles Mackinnon (Frederick Warne) – good reference book which is small and easy to carry in one's pocket.

SUPPLIERS OF ARTISTS' MATERIALS

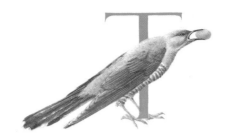

ENGLAND Reeves & Sons Ltd, Lincoln Road, Enfield, Middlesex

George Rowney & Co. Ltd, 10 Percy Street, London W1

Winsor & Newton Ltd, 51 Rathbone Place, London W1P 1AB (also shell gold and burnishers)

Vellum suppliers H. Band & Co., Brent Way, High Street, Brentford, Middlesex

William Cowley, Parchment Works, Newport Pagnell, Buckingham-shire

Paper specialists Falkiner Fine Papers, 117b Long Acre, Covent Garden, London WC2 (also calligraphic materials, quills, burnishers, shell gold)

Mastercraft Papers Ltd, Paper Mews, Dorking, Surrey RH4 1QX

Paperchase Products Ltd, 216 Tottenham Court Road, London W1

J. Barcham Green Ltd, Hayle Mill, Tovil, Maidstone, Kent

Gold suppliers – shell gold and leaf George M. Whiley Ltd, Firth Road, Houstoun Industrial Estate, Livingston, West Lothian EH54 5DJ

Winsor & Newton Ltd (*see above*)

U.S.A. Grumbacher, 460 West 34th Street, New York

The Morilla Company Inc., 43 21st Street, Long Island City, New York and 2866 West 7th Street, Los Angeles, California

Pentalic Corporation, 132 West 22nd Street, New York, N.Y. 10011

Winsor & Newton, 555 Winsor Drive, Secaucus, New Jersey 07094

INDEX

Page numbers in *italic* refer to illustrations and captions.